Contents

Frank Clarke 4

Introduction 5

1. Materials 6

2. Using Water with Acrylic Paint 13

3. Brush Strokes 14

4. Have Some More Fun 16

5. Beach Scene at Ballynakill Harbour 18

6. Snow Scene 34

7. Cleggan Beach 44

8. Still Life with Apple and Grapes 64

9. Gateway at Errislannan 80

10. Burren Flowers 96

11. Aasleagh Falls 108

A Word from Frank 127

Frank Clarke

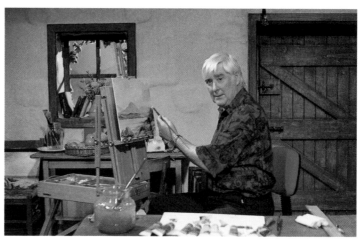

*Frank in his studio recording one of the Simply Painting
television programmes*

Born in Dublin, Ireland, Frank Clarke began painting just 15 years ago, and has since become one of Ireland's most well known and sought after artists.

During this time, Frank developed his artistic talents and a unique approach to painting which he calls **Have Some More Fun**. A natural teacher, Frank is convinced that anyone can paint and has travelled the world sharing his **Simply Painting** technique with a wide audience of young and old alike.

Using this method Frank has introduced thousands of people to the basics of watercolours and acrylics, the fun of painting, and realisation that "anyone who can draw the letter M can paint".

While painting now plays an important role in his life and has grown to include books, videos, television series and painting kits, he enjoys it so much that he still regards it as his "hobby gone mad".

With several successful television series screening on stations in the United States, United Kingdom and his native Ireland, Frank Clarke brings his skill, enthusiasm, and entertaining style to everyone to encourage, inspire, and instruct them how to paint.

In this book, Frank is eager to further share his hobby in his own relaxed and witty manner.

Introduction

Having finished a second book of lessons on watercolour painting and having had a holiday in the West of Ireland (painting of course), it's time to fulfil the many requests for a second book on acrylics. But rather than give you twenty cramped lessons, I am going to give you seven completely illustrated lessons in the same format as the ones in my first acrylic painting book, **Simply Painting Acrylics**. I know you will enjoy the variety of subjects I have chosen which are very different from each other.

But first, I'm asking you as we say in Ireland, "to hold your patience", and to read this book up as far as the first lesson <u>before</u> you start to paint. If you do, you will be rewarded with an understanding of how the **Simply Painting Have Some More Fun** method works and will realise just how simple and how much fun, painting can be. You will also have an understanding of the materials used for painting. If you do as I say, I know you will be painting in no time - I have never had a failure.

It's a funny thing, but with other hobbies, one does not have to start off as an expert. For example, with golf we are shown how to hold the club, how to stand, what clubs we need and how to use them. However for some crazy reason, a great number of painting instruction books assume we know everything before we start, at least that's what I discovered when I first started learning to paint. With painting, we are expected to be able to paint the Sistine Chapel (ceiling of course) without first being shown how to hold a paint brush and how to mix paints.

So without further ado let me introduce you to my good friend Mr. Brush who will help to guide you through this book.

1: Materials

Before you start painting, let me tell you something about the materials we are going to use for the lessons in this book.

Paints

Acrylic paint is a modern paint which was only invented about 40 years ago. It was not readily accepted because it was so different from the other paints which were available at the time.

However as someone who started to paint with watercolours and had only a limited knowledge of oil painting, I found acrylic paints had all the advantages I needed to make painting with them easy.

Acrylics are mixed with water and they dry at approximately the same speed as watercolours.

By drying quickly you can paint a background colour, let it dry (or use my secret weapon which I will tell you about later), and then paint other colours on top without producing the colour which is best known to many beginners who started with oil paints - **MUD**.

You can paint acrylics on almost any surface which is free of dust and oil and if you make a mistake you can just let them dry and then paint over them.

Acrylic paints are very versatile, you can paint thickly with them like oil paints or dilute them with water and use them like watercolours. You can even paint oil paints on top of acrylic paints (but not the other way around) and you can mix acrylic paints with watercolours.

In fact, acrylic paints are so easy to use, I believe they are the paint of the 21st century.

So let's talk about the colours we use. Some would say we have a limited palette, in that we use only eight tubes of paint to paint all these pictures. However, as you will soon find out, the number of colours we can make with these eight tubes is almost unlimited.

The paint I recommend you use for the lessons in this book in is Winsor & Newton Galeria Flow Formula Acrylic paint. It is inexpensive and is available in tubes and jars.

Tip: If you are painting in a very humid climate and you find the paints are drying too quickly, fill an atomizer with water and spray them regularly to prevent them drying out.

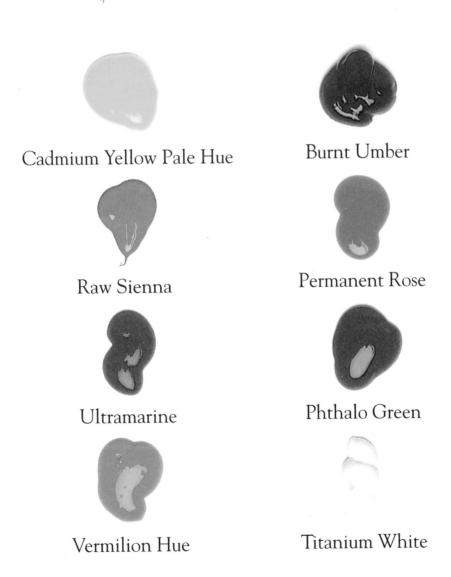

Cadmium Yellow Pale Hue Burnt Umber

Raw Sienna Permanent Rose

Ultramarine Phthalo Green

Vermilion Hue Titanium White

Canvas Board

Next we need something to paint on. As I said before, you can use acrylics to paint on almost anything. You can paint on paper, stretched canvas, canvas board, hardboard and most surfaces which are free of dust and oil.

You will find many different surfaces in art material stores on which you can paint, but the lessons in this book were all painted on Winsor Canvas Boards.

A canvas board is really a piece of stiff board with canvas stuck on it. Long ago, and even sometimes today, artists spent a lot of time sizing and priming their surfaces before they could paint. However we are very lucky as these boards are ready for immediate use and there is no need to waste time on priming and preparing. These canvas boards can be used again and again, because if you paint something you don't like, you can just paint over it.

The canvas boards are inexpensive and are readily obtainable in many sizes at most good art stores.

You should use 14" x 10" (35.5cm x 24.5cm) boards for the lessons in this book.

Brushes

You only need three brushes. to paint all the lessons in this book. I use the *Simply Painting Acrylic* brushes which now have yellow handles to differentiate them from the *Simply Painting Watercolour* brushes, which have green handles.

First of all the largest brush we use is the *Simply Painting Large Acrylic Brush*. It is about 1.5" (38mm) wide and made of bristle.

Next we have the medium brush, which is the *Simply Painting Medium Acrylic Brush*. It is a No. 4 filbert brush which is a flat brush with a rounded top. The meaning of the word filbert is that the top is rounded.

The third brush is the *Simply Painting Small Round Acrylic Brush*. It is a small round No. 3 or No. 4 nylon brush, which has long hair and is used for putting detail in your pictures.

These brushes are manufactured by Winsor & Newton and are available through all their stockists. To get started you can use any bristle brushes, but I recommend you use the *Simply Painting* brushes.

Important: While you are painting, you should keep your large and medium brushes in the water otherwise they will become hard. In the case of the small brush clean it every time you use it during a painting session and leave it aside. When you are finished painting clean your brushes thoroughly and put them aside.

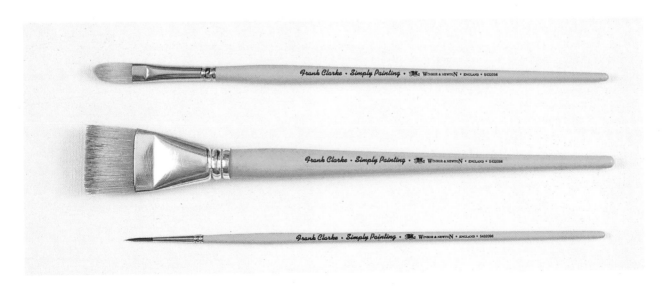

Easels

When painting with acrylics most people use an easel to hold the canvas board upright so let me tell you a little about easels.

There are many kinds of easels, wooden easels, metal easels, table easels and box easels. They each have their own advantages. For example metal easels can generally hold your surface upright or horizontal so they can be used for painting either watercolours or acrylics. Table easels on the other hand are smaller and very convenient where space is limited. I often use a table easel which sits on the table when I am painting and folds down flat, when I don't need it.

My favourite easel when I'm painting acrylics is the Winsor & Newton box easel. It's really only a wooden box with legs. It holds most of the materials I use and I can just close it up and take it outside to paint. When I come home I can use it to paint in my studio - it acts as a carrying case. It has only one problem, and that is, it's not cheap. However, it is a ideal gift, so you might want to mention to friends or relations that your birthday is coming soon.

After all I have said about easels, I should say that an easel is not an essential part of painting. The best thing about the canvas boards we use is that you can even paint with them on your knee, but be careful not to get any paint on your clothes as it may be impossible to remove.

If you are painting at home, you can put your canvas board on the table and raise the back with a block of wood, or something similar behind it and off you go. However, I do find that an easel is a help.

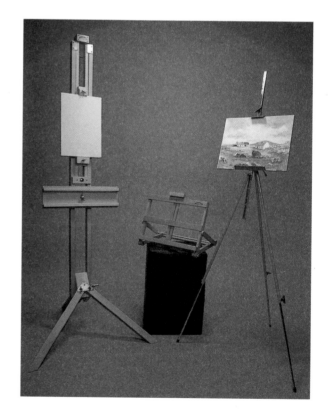

Palette

You need a palette to put your paints on. I use a **Simply Painting Acrylic Palette** which has a hole in which to place your thumb to hold it. It is white and made of plastic. It measures approximately 16" x 12" (40.5cm x 30.5cm).

If you don't have one of these you can use a large expendable palette. This is a palette made with sheets of coated paper and a hard cardboard backing. You mix your paints on the top sheet and when you are finished just tear it off and throw it away. They are very convenient when painting outdoors as you don't have to clean your palette when you are finished. Most art stores stock them in several sizes.

If you don't have either of these I suggest you use a large white plate or tray. The reason it should be white is that you will be better able to see the colours you are mixing. Make sure it is fairly large so you have enough room to mix your colours.

Your palette should also have a smooth surface which can be cleaned with water and a pot scrub.

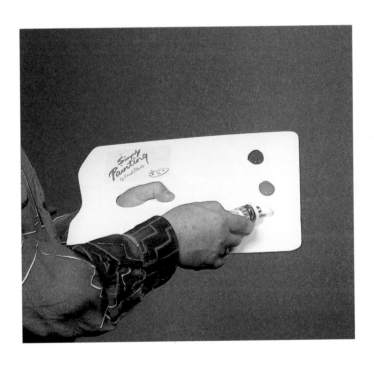

Other Materials

The other materials you will need for the lessons in this book include:

- A large container of water which is used for cleaning your brushes and diluting the paint

- A cloth to dry your brushes on, and control the amount of water on them

- A pencil and a ruler

- An apron or some old clothes

- A hairdryer, if you have one.

2: Using Water with Acrylic Paint

If you have read any of my previous books you will be familiar with the next three chapters and will realise how important they are. So forgive me for repeating them here and perhaps take the opportunity to read them again. If you have never used the **Simply Painting** methods before then these chapters will help you to get good results first time.

When painting with acrylic paints I prefer to use the paint directly from the tube and not to dilute it with water. By keeping your brushes in water while painting, they will retain enough water even after you dry them, to make the paint moist.

When applying paint to the canvas board do the following:

1. Take your brush from the water container and dry it on an old cloth. It does not need to be completely dry, just remove the excess water.

2. With the brush still damp, pick up some paint and use it to paint the picture.

3. When you want to change to another colour just dip your brush into the water container and clean it, making sure to remove all the paint. Then dry it on your cloth and off you go again.

3: Brush Strokes

Each of the brushes are used in many ways to produce different strokes. The **Simply Painting Large Acrylic Brush**, with which you will paint most of your picture, can take the place of three brushes when used in the following different ways:

Firstly, as a large flat brush to paint broad brush strokes.

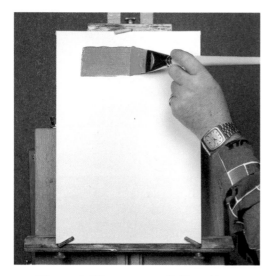

Broad Horizontal Strokes

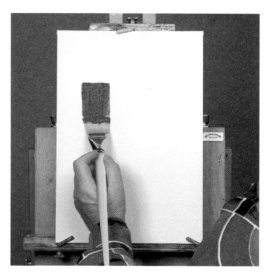

Broad Vertical Strokes

Secondly if you look at the brush on its edge, it is quite narrow and that gives us a second brush which we use to paint narrow brush strokes.

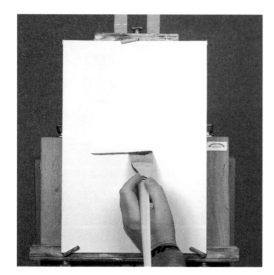

Narrow Horizontal Strokes

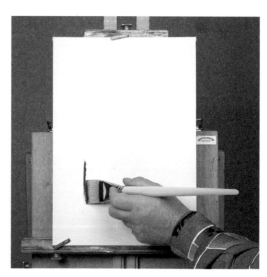

Narrow Vertical Strokes

Corner Brush Strokes

Corner Brush Strokes

Thirdly by painting with a smallest part of the large brush, i.e. the corner, we get a third use out of the large brush - corner brush strokes. These strokes are very useful for painting trees.

Scumbling Brush Strokes

The *Simply Painting Medium Acrylic Brush* is used for detail and to finish your clouds. It is great for scumbling clouds. What do I mean by scumbling? Simply moving the brush back and forward using a flat rapid stroke.

Scumbling Brush Strokes

The *Simply Painting Round Acrylic Brush* is used like a pen to draw fine details.

Note: These are just some of the brush strokes you can use. The more you practice the better you will become. Why not try them out for yourself?

4: Have Some More Fun

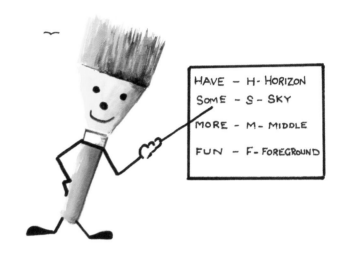

HAVE — H - HORIZON
SOME — S – SKY
MORE — M - MIDDLE
FUN — F - FOREGROUND

Do you believe me when I say, 'anyone can paint' - well I've got bad news for you, it's the truth! We can all paint, just many of us haven't been shown how. My intention with **Simply Painting** is to show you how.

While everyone can paint somebody has to show you how to start. For example, if nobody showed you how to start ABC in school, you'd never know how to read or write. I am going to show you the ABC of painting and it's very simple.

What you do is break the painting into elements or stages. My method is called **Have Some More Fun**. which stands for **H**orizon, **S**ky, **M**iddleground and **F**oreground. If you take the first four letters of **Have Some More Fun**, **H S M F**, you will remember Horizon, Sky, Middleground and Foreground and this is the order in which we paint our pictures.

Have	=	H	=	Horizon
Some	=	S	=	Sky
More	=	M	=	Middleground
Fun	=	F	=	Foreground

First paint the horizon line across the painting, then the sky above it, next the middleground and finally, the foreground. The middleground is everything between the horizon line and the sky. The foreground is everything below the horizon line. When you break your painting into these four stages, it makes it very simple.

That is how we construct our picture.

Have

First we draw our horizon line, always straight across the board.

Some

Starting at the top of your picture and keeping above the horizon line paint the sky.

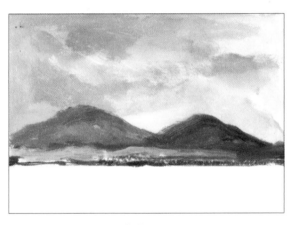

More

Next just above the horizon line paint in a letter "M" to represent the mountains.

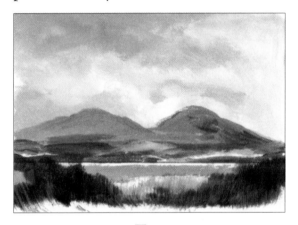

Fun

Lastly we paint the foreground.

This book can be used on its own as it is self-explanatory but it can also be used in conjunction with my first book, **_Simply Painting Acrylics_**, which it shows you how to paint figures in landscapes, boats, bridges, water, trees and many other items and also has a very useful colour chart to help when you are mixing colours.

Having read the chapters on materials and how to start, I'm sure by now you will realise that by using the **_Have Some More Fun_** method, you will be able to paint, so let's get to our first lesson.

17

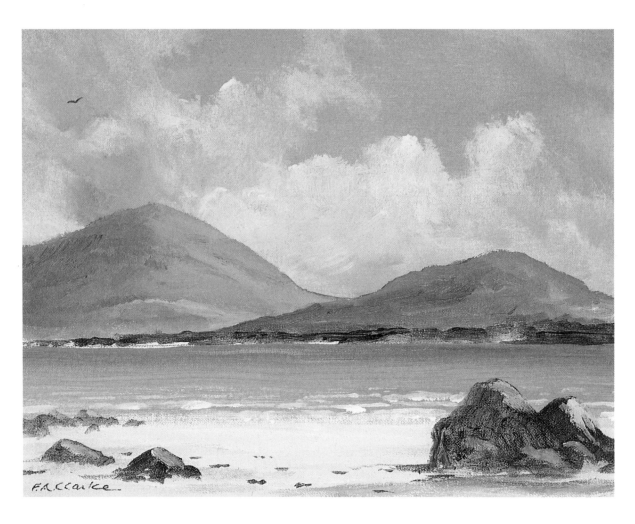

BEACH SCENE AT BALLYNAKILL HARBOUR

FOR THIS LESSON YOU WILL NEED THE FOLLOWING MATERIALS
14" x 10" (35.5CM x 24.5CM) WINSOR CANVAS BOARD
1.5" (38MM) *Simply Painting* LARGE ACRYLIC BRUSH
Simply Painting MEDIUM ACRYLIC BRUSH
Simply Painting ROUND ACRYLIC BRUSH
Simply Painting PALETTE OR A LARGE WHITE PLATE OR TRAY.
WATER CONTAINER • OLD CLOTHS • A PENCIL AND A RULER
AN EASEL AND A HAIRDRYER, IF YOU HAVE THEM.

ACRYLIC PAINTS
TITANIUM WHITE • RAW SIENNA • ULTRAMARINE BLUE
CADMIUM YELLOW PALE HUE • BURNT UMBER

18

5: Beach Scene at Ballynakill Harbour

County Galway on the west coast of Ireland is considered one of the most scenic areas in the country. It is a real painter's paradise.

The first scene we are going to paint is near Letterfrack, looking across Ballynakill Harbour in Connemara. It is quite near my studio and I think it depicts exactly what I mean when I say, **Have Some More Fun** - Horizon, Sky, Middleground and Foreground.

Look at the scene we are going to paint and apply the **Have Some More Fun** method. You will notice the horizon line is just below the mountains. Above the horizon line is the sky. The middleground is the mountains, which look like the letter M and in the foreground there is sea, sand and rocks.

Read the lesson in full, before starting to paint.

This picture is painted in landscape, so set your canvas board resting on one of its long sides. If you have an easel, use it, but if you don't, you can rest it on a table and raise the back of the canvas board about 2".

14"

10"

Step 1: Have - Horizon Line

So without further ado, let's start our first painting. For this lesson, you will notice we only need five of the eight colours. So squeeze some Ultramarine Blue and Titanium White onto the edge of your palette and put your large and medium brushes into the water.

Now, just below the centre of the canvas board, draw the horizon line using your pencil and the ruler.

Step 2: Some - Sky

I use the large brush for painting 90% of the picture because it is quicker. So, take the large brush out of the water and dry it on the cloth. I hope you read the chapter on controlling water on your large brush, if not, do so now (see Chapter 3 Using Water with Acrylic Paint).

The percentages given for each colour in the lessons are only approximate, you can adjust these to suit your own taste. Take some Titanium White with some Ultramarine Blue, 75% Titanium White and 25% Ultramarine Blue, and drag it to the centre of the palette.

Starting from the top of the canvas board, paint the sky down towards the horizon line. In this case paint an even coat of blue, just as you would paint your back door.

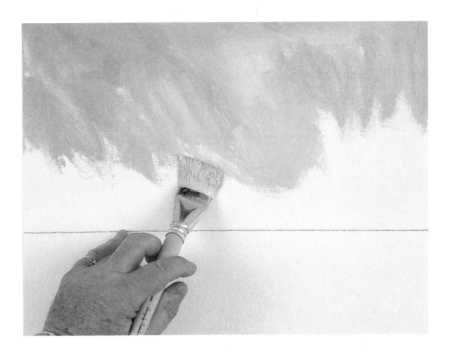

Tip: If the phone rings or someone calls, put your brushes into the water before answering it.

To soften your sky, draw your large brush across the canvas board very lightly. Then put your brush back into the water.

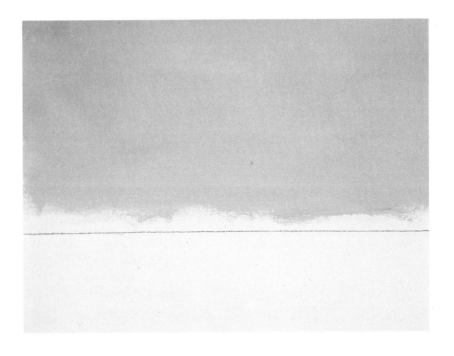

Now, I want to add in some Titanium White for clouds. This is were acrylic paint excels. I can let the first coat of paint dry, and then paint some Titanium White on top to represent clouds; without letting the Titanium White mix with the background colour. I use my hairdryer to speed up the drying process. You can use a hairdryer if you have one, if not, wait until the paint has dried.

When it has dried, take the large brush out of the water and dry it on the cloth. If you look at the finished painting, you will see where the white clouds are in the sky.

Dip the large brush into the Titanium White and paint some clouds. Use a scumbling stroke, which is a back and forward movement of the brush, using short strokes (see Brush Strokes Chapter 3).

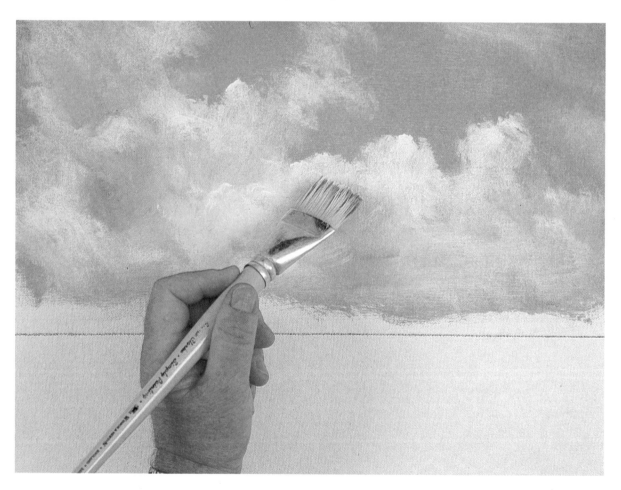

Tip: If you find any hairs falling from the brush, just remove them, don't worry about them as it is very common with a new brush.

Step 3: More - Middleground

If you can draw the letter M, you can paint mountains, because they are really only letter M's. First of all, look again at the finished picture to see what colours you need. The mountain in the background is a greyish colour and to paint it you need to add one more colour to the Ultramarine Blue and Titanium White you have on your palette.

So put out some Raw Sienna on the edge of the palette. If you need to, you can also put out more Titanium White.

Now using Titanium White, Ultramarine Blue and Raw Sienna, about 1/3 of each, mix them in the centre of the palette. This will give you a darker blue/grey colour than the sky. You don't have to mix the colours too much on the palette, let them mix on the canvas board.

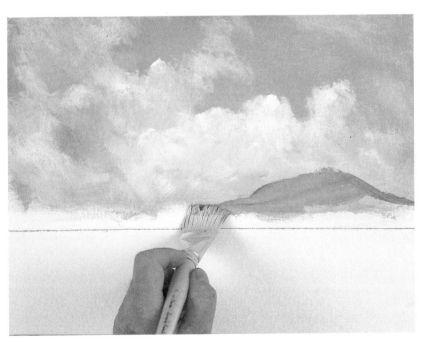

Use this colour to paint all the mountains, even though in the finished painting, the mountains on the right are different colours. So, starting from the right hand side, paint the letter M, first the smaller mountain and then the larger one.

23

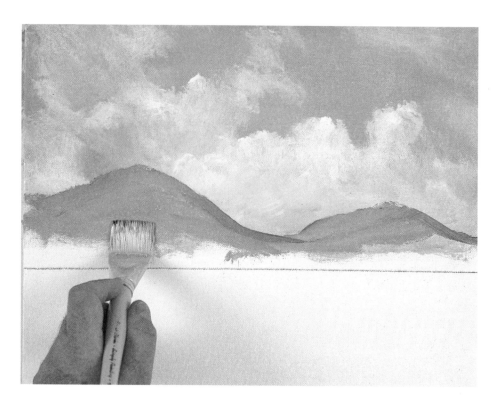

Now, let's concentrate on the larger mountain and lighten the right hand side. Clean your large brush in the water and dry it on the cloth. Add some Titanium White to the mix on your palette and paint the right hand side of the mountain while the mountain is still wet.

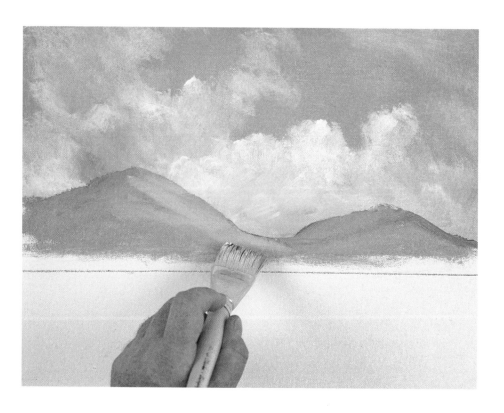

Now, to darken the left hand side of this mountain, wash your brush and dry it on the cloth. Add a little more Ultramarine Blue to the mixture and paint the left hand side. This will give the effect of light and shadow on the mountain. Before continuing, dry the painting with a hairdryer or wait for the paint to dry.

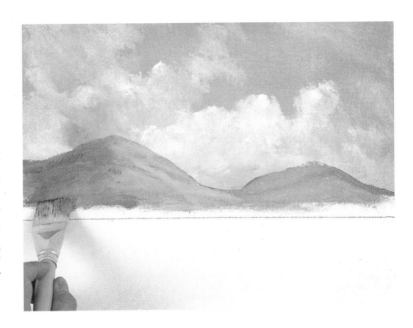

Now, let's paint the green mountain on the right hand side.

Using the medium brush, take it out of the water and dry it on the cloth. Mix 75% Cadmium Yellow Pale Hue and 25% Ultramarine Blue on the palette and paint over the small grey mountain on the right hand side.

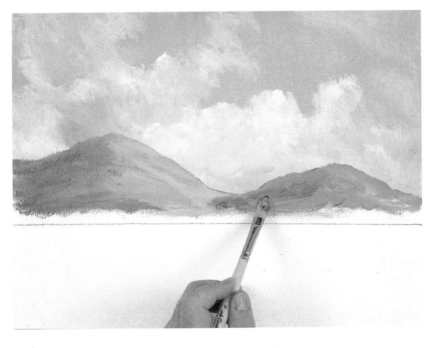

Now dip your medium brush into the water, and clean and dry it on the cloth. I want to add some light colour using Titanium White, Cadmium Yellow Pale Hue and Raw Sienna, 1/3 of each, to paint under the mountains, to the left of the small mountain.

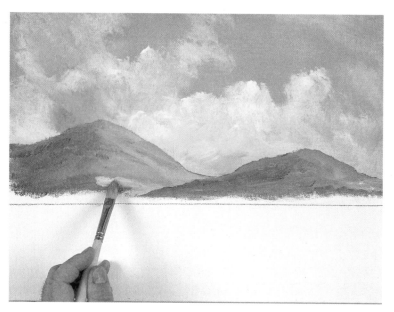

Using Titanium White, Ultramarine Blue and Cadmium Yellow Pale Hue, paint a darker area at the base of the mountain, to the left of the area we have just painted.

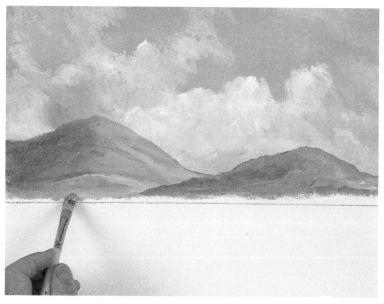

If you use too much Ultramarine Blue and make the mixture too dark, simply clean your brush in the water, dry it off on the cloth and add pure Cadmium Yellow Pale Hue to the mixture on the canvas board to lighten it. Put your medium brush back into the water and clean it thoroughly.

Now, put out some Burnt Umber onto the palette and take your medium brush from the water and dry it on the cloth. Using 1/3 Raw Sienna and 2/3 Burnt Umber, paint the distant coast just above the horizon line.

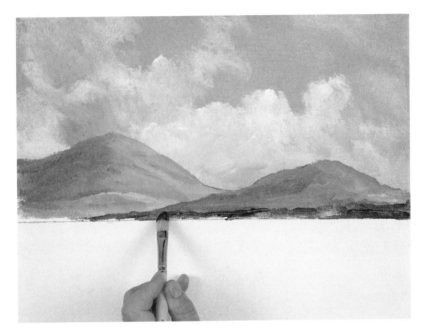

Put the brush back into the water and clean it. Now dry the painting.

Step 4: Fun - Foreground - Sea, Sand and Rocks

Next paint the sea. Take the large brush from the water and dry it on the cloth. Now, using Ultramarine Blue with some Titanium White, mix the same blue as you did for the sky.

Starting under the horizon line, paint the sea down to about 2" from the bottom of the canvas board. Put your brush into the water and clean it. Then let your picture dry.

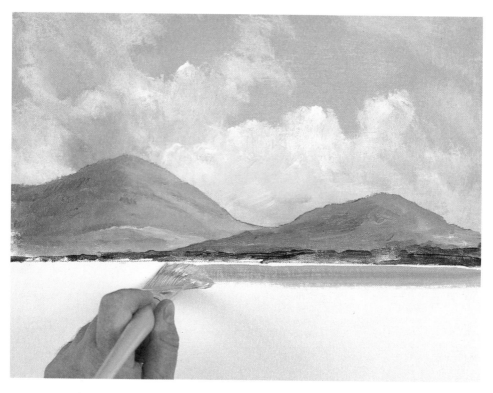

Next let's paint the beach. Use 75% Titanium White and 25% Raw Sienna, with your large CLEAN brush to paint the beach.

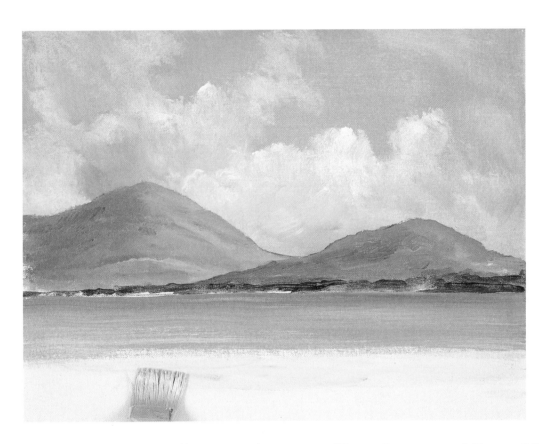

Now, while the beach is still wet, with a mix of Raw Sienna and Burnt Umber, equal amounts of each, paint some shadows on the sand. Don't overdo it.

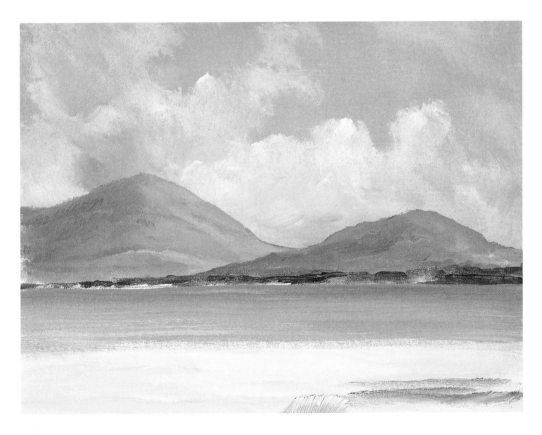

Now, let's paint some rocks in the foreground. The rocks are a mixture of Burnt Umber, Ultramarine Blue with a little Titanium White. This time, use a mix of these colours you think looks best.

Take your medium brush from the water and dry it on the cloth. Using this mixture, paint the rocks in the right foreground first.

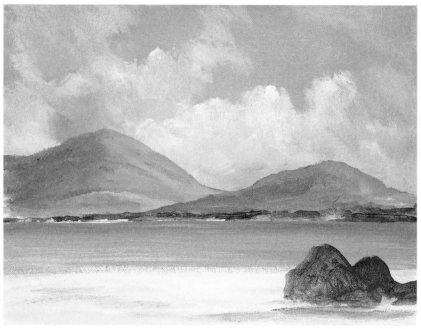

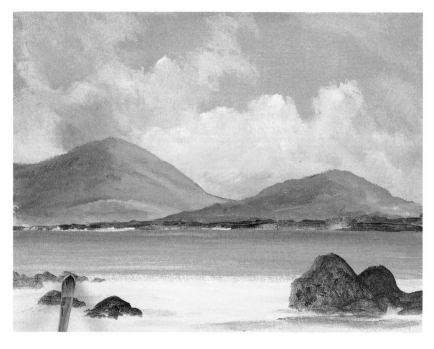

Next, paint the rocks on the left of the beach. Add a little more Titanium White to the mix on your palette and paint the outcrop of rock on the left hand side, which juts out into the sea

To give the rocks better shape, we put some light and dark areas on them. However, it is a good idea to allow the rocks to dry before painting these highlights and shadows. So using your hairdryer, dry the rocks on the beach.

Now, with the mix you used to paint the outcrop on the left hand side of the beach, paint some highlights on the right of each rock. You can even paint some pure Titanium White on the tops of the rocks.

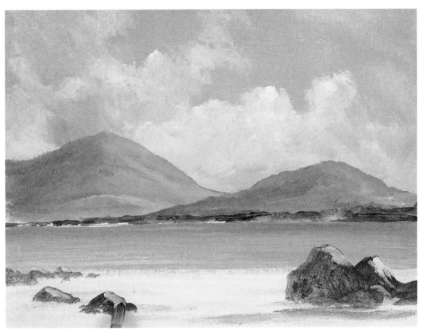

Now, clean your medium brush and dry it on the cloth. Pick up some Titanium White and paint some waves on the sea, close to the shore. Use narrow horizontal strokes, but again don't overdo it.

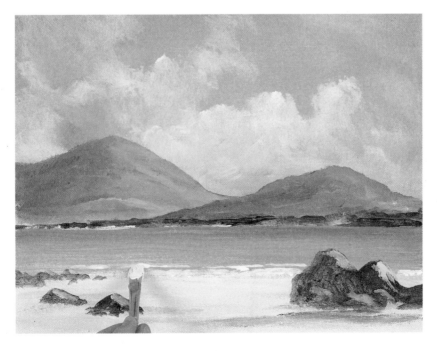

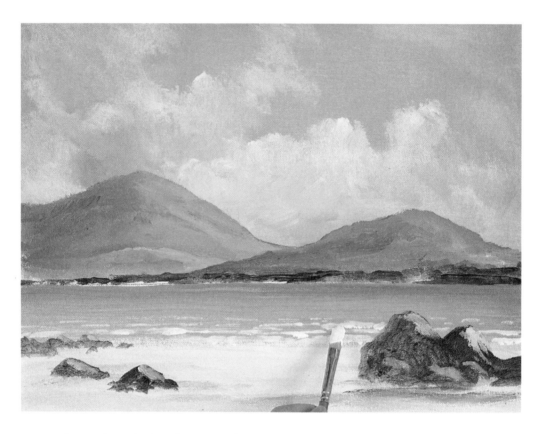

Put your medium brush back into the water and clean it thoroughly. Now, using the small brush, paint some debris on the sand with some Burnt Umber only.

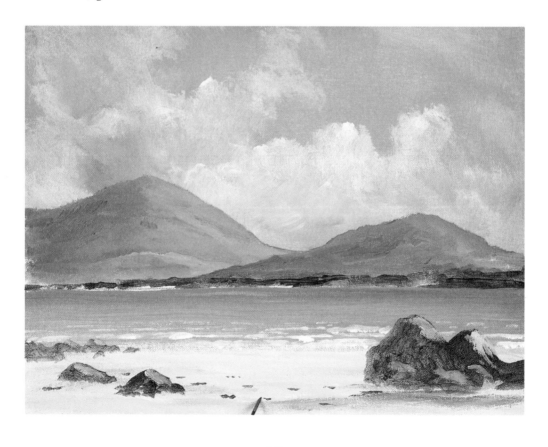

Finally, using the small brush and some Burnt Umber, paint a little bird in the shape of a flat V. Remember don't make one wing larger than the other - both wings should be the same size.

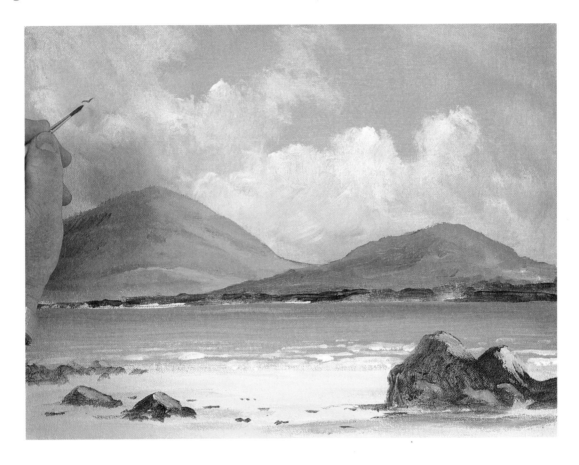

Now all that's left to do is to sign it.

Congratulations, that completes this first lesson, but you can of course repaint it using different shaped mountains, maybe some from your own area.

Snow Scene

FOR THIS LESSON YOU WILL NEED THE FOLLOWING MATERIALS
14"x 10" (35.5CM x 24.5CM) WINSOR CANVAS BOARD
1.5" (38MM) *Simply Painting* LARGE ACRYLIC BRUSH
Simply Painting MEDIUM ACRYLIC BRUSH
Simply Painting ROUND ACRYLIC BRUSH
Simply Painting PALETTE OR A LARGE WHITE PLATE OR TRAY
WATER CONTAINER • OLD CLOTHS • A PENCIL AND A RULER
AN EASEL AND A HAIRDRYER, IF YOU HAVE THEM.

ACRYLIC PAINTS
TITANIUM WHITE • RAW SIENNA
ULTRAMARINE BLUE • BURNT UMBER • VERMILION HUE

6: Snow Scene

Snow scenes can be very beautiful and are very easy to paint when you use the *Simply Painting* method. I know you will enjoy painting this snow scene, and when finished your friends will admire it. It might even make a very nice present for one of them.

Step 1: Have - Horizon Line

Firstly, set the canvas board on your easel in landscape fashion, that is, resting on its long side. Next, using a pencil, draw the horizon line approximately one third of the way up the canvas panel.

Step 2: Some - Sky

Put your large brush and your medium brush into the water. Now, take your large brush from the water and dry it on the cloth. With a mixture of Titanium White and Vermilion Hue, approximately 80% Titanium White and 20% Vermilion Hue, paint in the background for the sky.

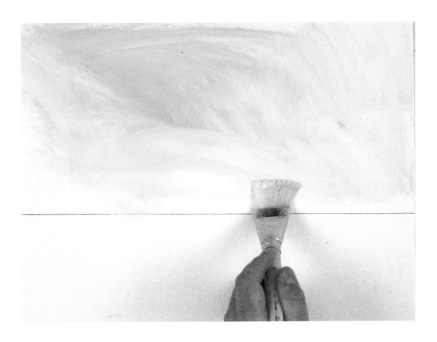

While the background is still wet, add in some Titanium White and Ultramarine Blue, 50% of each, to the mixture on your palette and, paint the rest of your sky.

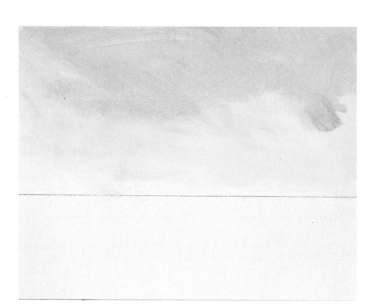

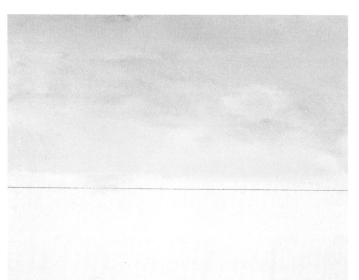

Now, holding the brush very lightly, draw it across the canvas board using broad horizontal brushstrokes, from right to left, or left to right (see Brush Strokes Chapter 3). This will soften your sky.

Now, just add in some Titanium White to the centre of your sky and once more, draw your large brush across the canvas board very lightly to soften it.

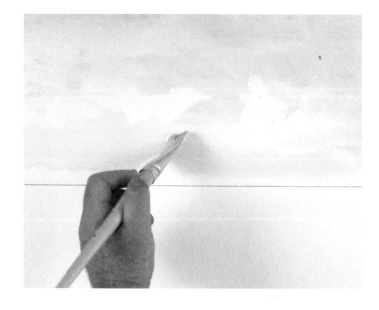

Step 3: More - Middleground

Now, without drying the sky, mix some more Titanium White, Vermilion Hue and Ultramarine Blue - about 1/3 of each. It is not necessary to clean your brush before doing this.

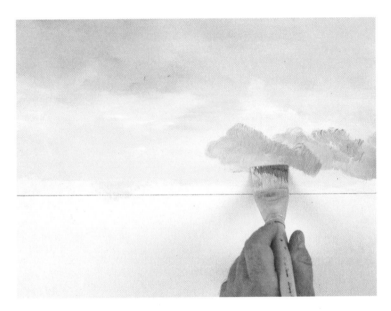

Dab in the trees in the background. Keep them about one inch above the horizon line.

Having completed the trees dry the painting before continuing. Use your hairdryer if you have one, otherwise wait until it has dried.

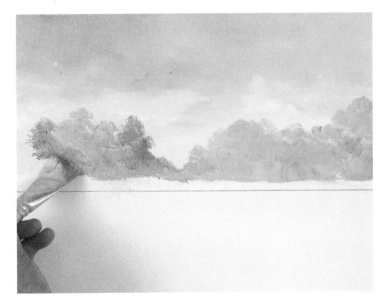

Our next step is to paint the bushes in the middleground. These are painted using Burnt Umber, mixed with the red and blue mixture on your palette. So, put out some Burnt Umber onto your palette. With equal amounts of Vermilion Hue and Burnt Umber and the mix of red and blue on your palette, paint the bushes right down to the horizon line.

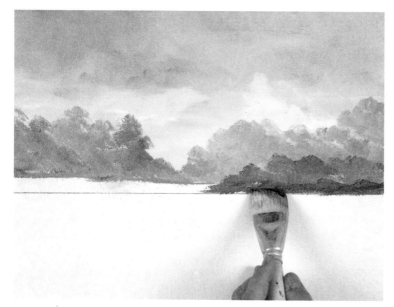

Use slightly darker paint on the horizon line itself by adding some more Ultramarine Blue into the mixture. Do the same on the other side of the canvas panel. If it is too dark, you can add Titanium White to lighten it and, if it is too light you can add more of the Burnt Umber.

Now, put your large brush back into the water and clean it. Take the medium brush with Titanium White and paint the snow between the two ditches. Add a tiny bit of red to this, to give it a slight hue.

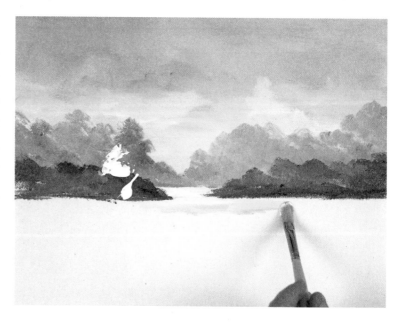

Carry on with the Titanium White and paint right to the bottom of the picture, using the medium sized brush. You can add in a tiny bit of the red and blue to create shadows, just enough to barely tint it. When you are finished, put your medium brush back into the water.

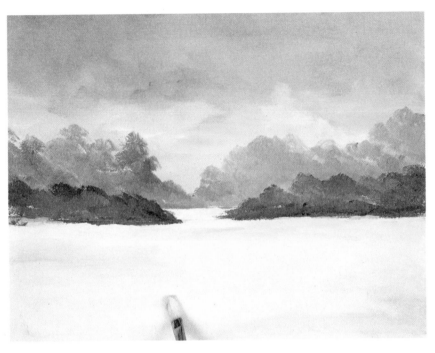

Now, in the centre of the picture, using the large brush with a mixture of 60% Titanium White, 20% Ultramarine Blue and 20% Vermilion Hue, paint the water. For this mixture make your paint inky (or weak) by adding more water. If you find it is too dark, add some more Titanium White.

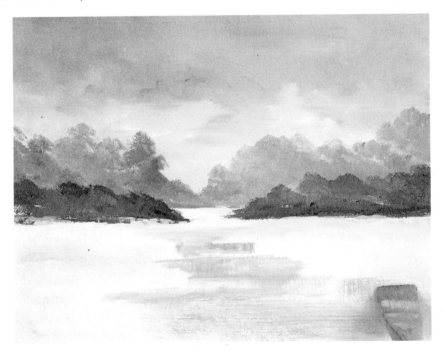

Having completed the water in the centre of the picture, use the large brush with 75% Raw Sienna and 25% Burnt Umber to paint some reeds.

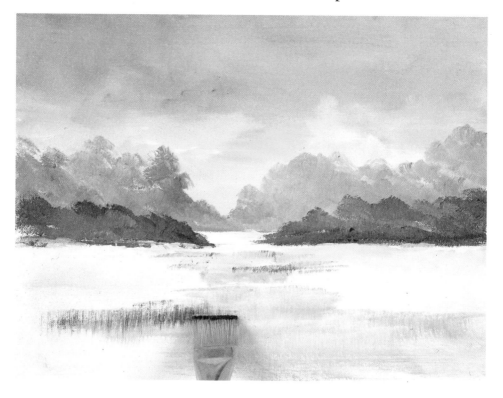

Now, using mainly Burnt Umber, with downward strokes of the large brush, paint some more reeds and this completes our riverbank.

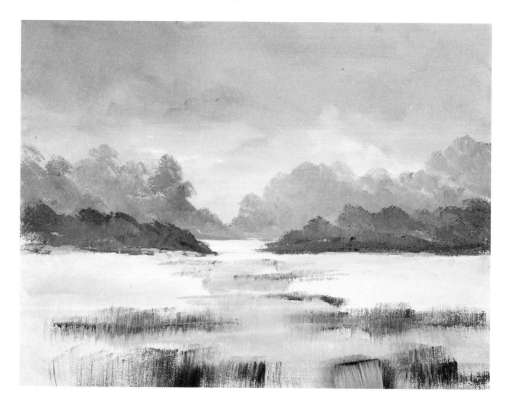

Now, with the small brush, the next thing we need to do is paint the tree.

So, using the small brush with a mixture of Burnt Umber and a tiny bit of Vermilion Hue, paint the tree.

Take your time, paint the skeleton of the tree first and always remember to start from the ground and work up.

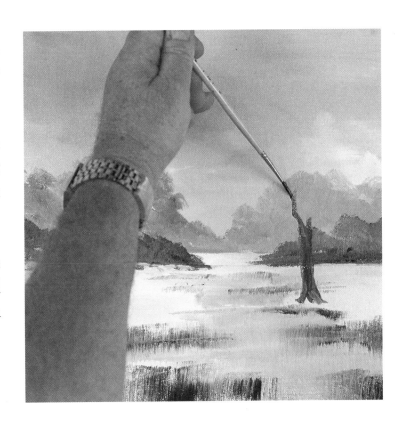

Tip: Don't place the tree in the centre of the picture.

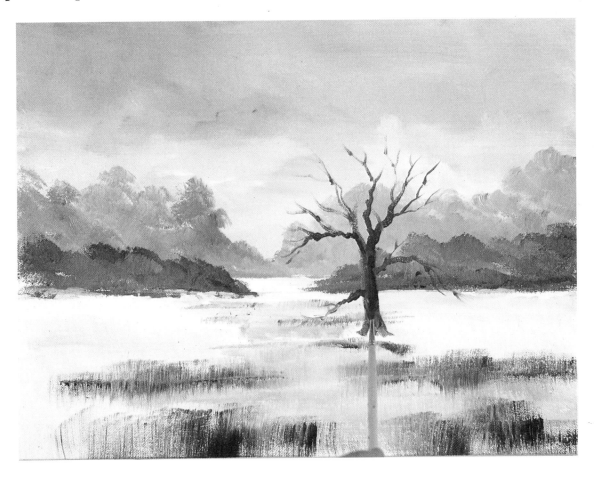

41

Having completed the tree, the next thing we have to do is to put the twigs on the tree. They are not leaves, they're twigs, because of course it's winter. To do this, you need to make a mixture with equal amounts of Titanium White, Vermilion Hue and Ultramarine Blue. Just dab it on with the corner of the large brush but make sure that the brush is reasonably dry (see Brush Strokes Chapter 3).

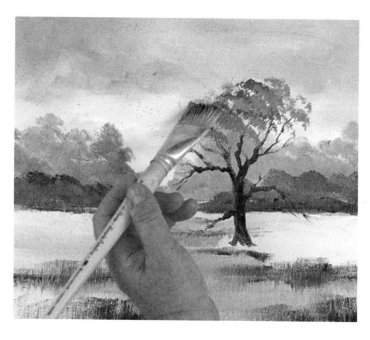

Next, let's paint the small fences on the right and left of the picture. Use the small brush with some Burnt Umber only. Start with the fence on the right and make sure you don't make them too uniform. You can see the picture is coming together now, just a few small touches before you finish.

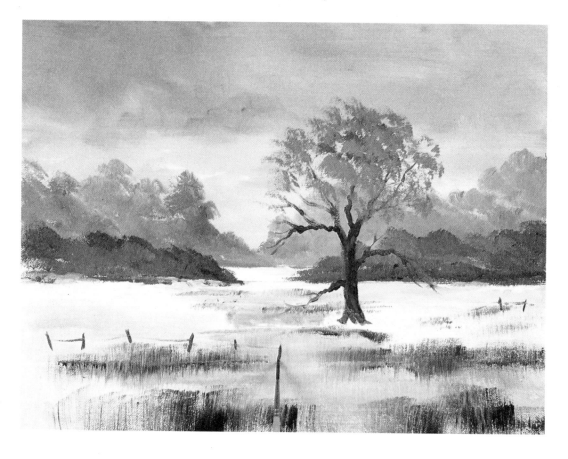

Take the small brush with lots of water and make an inky mixture of Burnt Umber. Now use this mixture to paint the reflection of the tree on the water.

While we are painting reflections, you will notice that the sky has some pink which is reflected on the water.

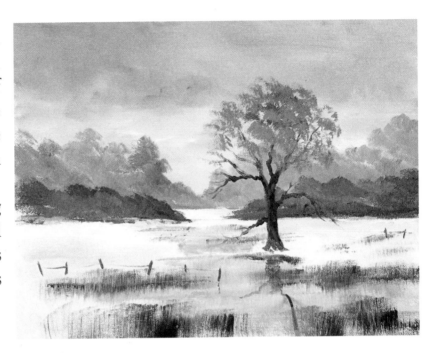

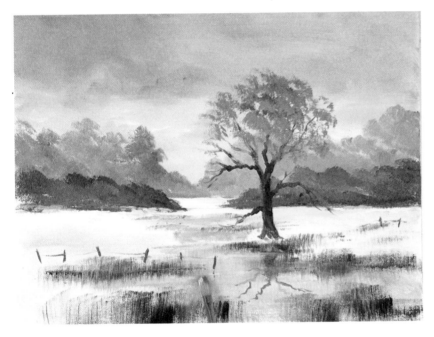

So take the medium brush with Titanium White and a tiny amount of Vermilion Hue, 90% Titanium White and 10% Vermilion Hue, and paint some reflections of the sky on the water, but don't overdo it.

Now, create a few tall reeds with some Burnt Umber and upward strokes of the small brush, and again don't overdo it, look at the finished picture before starting to paint.

Congratulations!

Now, sign your painting.

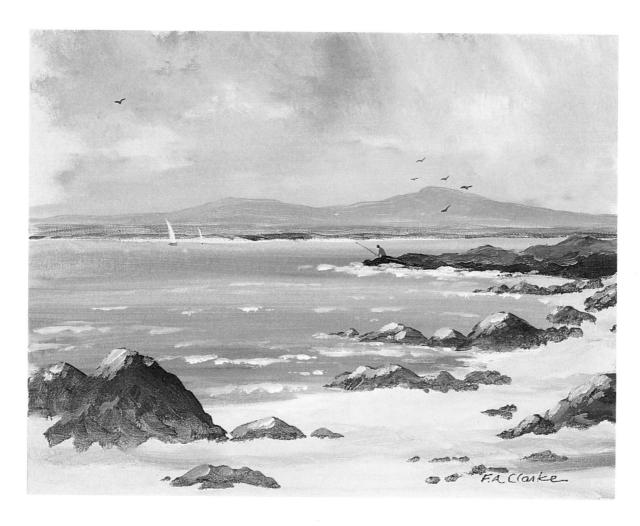

CLEGGAN BEACH

FOR THIS LESSON YOU WILL NEED THE FOLLOWING MATERIALS

14" x 10" (35.5CM x 24.5CM) WINSOR CANVAS BOARD
1.5" (38MM) *Simply Painting* LARGE ACRYLIC BRUSH
Simply Painting MEDIUM ACRYLIC BRUSH
Simply Painting ROUND ACRYLIC BRUSH
Simply Painting PALETTE OR A LARGE WHITE PLATE OR TRAY
WATER CONTAINER • OLD CLOTHS • A PENCIL AND A RULER
AN EASEL AND A HAIRDRYER, IF YOU HAVE THEM.

ACRYLIC PAINTS

TITANIUM WHITE • CADMIUM YELLOW PALE HUE
RAW SIENNA • ULTRAMARINE BLUE • BURNT UMBER
VERMILION HUE • PHTHALO GREEN

7: Cleggan Beach

I enjoyed painting this picture immensely as it was a lovely evening and I painted it on site. If you look at the finished painting you will notice, it is a seascape with a few boats on the water, and a fisherman on the rocks. In the foreground, there is a beach with some rocks and sand. So let's paint it.

Step 1: Have - Horizon Line

The first thing we do is draw the horizon line. So, using a ruler and a pencil, draw the horizon line just above the centre of the canvas board, which in this case is set up in landscape fashion (longways).

Tip: The horizon line is never in the dead centre of the canvas board, it's always either above or below.

Step 2: Some - Sky

In this picture, we are going to use four colours to paint the sky. So, put out some Titanium White, Ultramarine Blue, Phthalo Green and Raw Sienna on your palette.

Tip: Keep the colours to the side of your palette, it leaves more room for mixing your paint.

Take some Titanium White to the centre of the palette and add a little Raw Sienna, about 80% Titanium White and 20% Raw Sienna will do.

We are going to create a wash on the canvas board. So, take your large brush from the water and dry it on the cloth. Using back and forward strokes, paint the sky down to the horizon line.

While the paint on the canvas board is still wet and, without cleaning your brush, take some Titanium White to the centre of the palette and add some Ultramarine Blue about 25% Titanium White and 75% Ultramarine Blue.

Using the large brush, paint some of this mixture on the canvas board. Do not cover the entire sky with this colour, as we want some of the backround colour to show through in the finished painting.

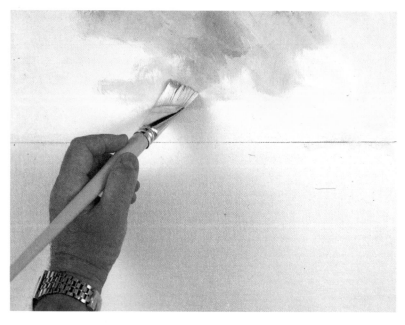

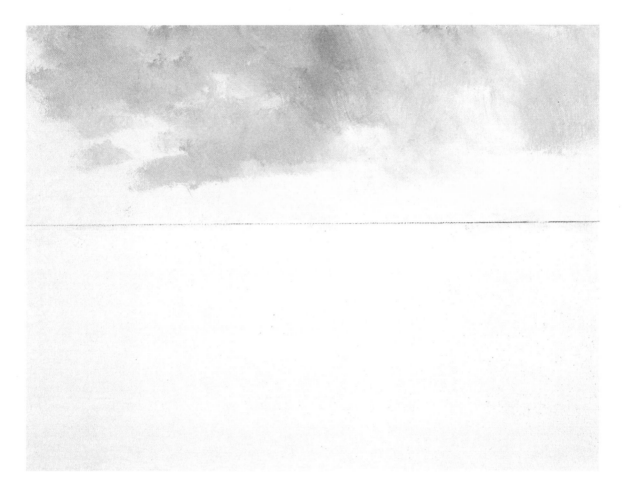

Now let's add Phthalo Green into the sky. The reason we add Phthalo Green is so that the sky and sea will match one another. The sea is going to have Phthalo Green in it, so we want make sure there is some in the sky first.

Clean your large brush in the water and dry it on the cloth. Now take some Titanium White to the centre of the canvas board and add a tiny amount of Phthalo Green to it. Paint the sky just above the horizon line with this colour.

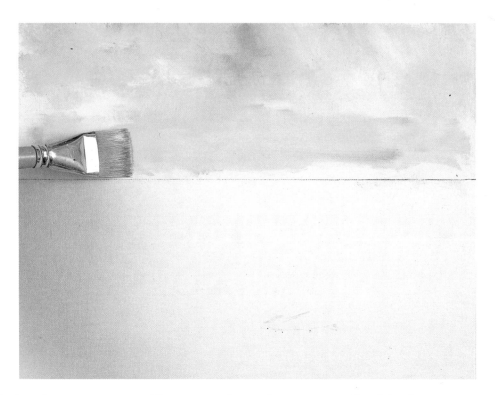

Now, while the paint is still wet, soften the entire sky by dragging your large brush lightly across the canvas board using broad horizontal brush strokes (see Brush Strokes Chapter 3). Let your brush barely touch the canvas board and it will give a nice even texture to your sky.

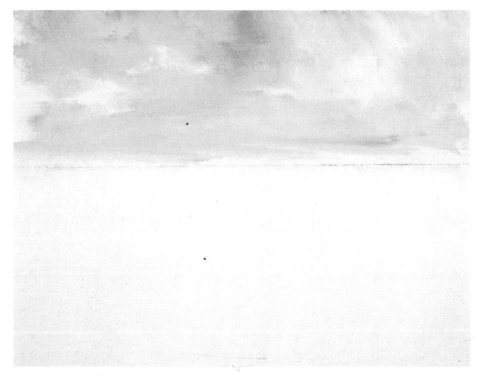

Now, dry the sky with your hairdryer or wait and let it dry naturally.

Step 3: More - Middleground - Mountains

Next using the medium brush, let's paint the mountains. Remove the brush from the water and dry it on the cloth. Now take some Titanium White, Raw Sienna and Ultramarine Blue - almost 50% Titanium White and 50% Raw Sienna with a tiny amount of Ultramarine Blue, onto the medium brush.

Use this mixture to paint a flattened M on the canvas board, just above the horizon line.

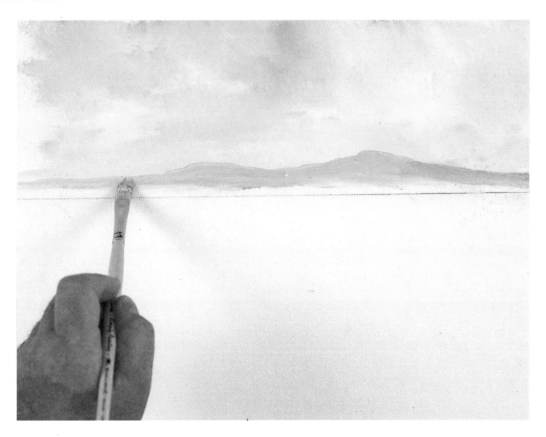

Now, put out some Burnt Umber on th
palette. Using Raw Sienna and a litt
bit of Burnt Umber, paint the are
between the mountains and the horizo
line.

Now, to give the impression of a distant shoreline, using Burnt Umber only, outline the shoreline just along the horizon line.

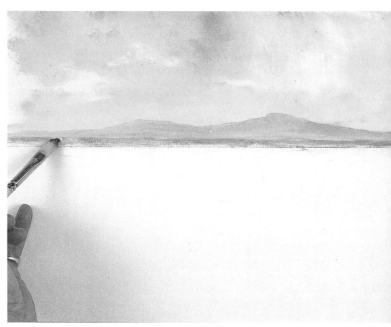

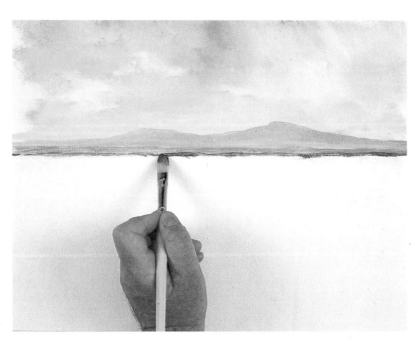

Again use the mediu
brush and paint wit
narrow horizontal stroke
(see Brush Strok
Chapter 3).

Put your medium brus
back into the water ar
clean it thoroughly. No
you are ready to paint th
sea.

Step 4: Fun - Foreground - Sea

Take your large brush from the water and dry it on the cloth. For the sea, we need some Ultramarine Blue and Titanium White. Take 75% Titanium White and add about 25% Ultramarine Blue.

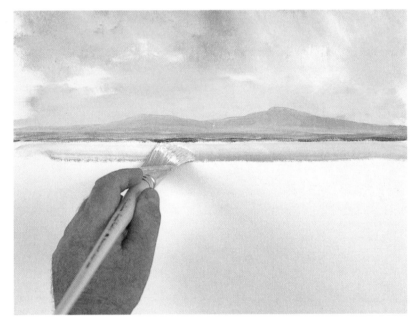

Using narrow horizontal strokes (see Brush Strokes Chapter 3), paint the sea below the horizon line.

As you move down from the horizon line use broad horizontal strokes. (see Brush Strokes Chapter 3).

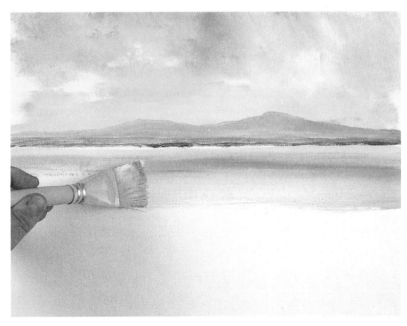

Once this is completed, we are ready to paint the Phthalo Green in the sea. So, without cleaning your large brush, using the same mixture of Titanium White and Ultramarine Blue, add a little Phthalo Green to it. Paint the sea starting about 2" below the horizon line.

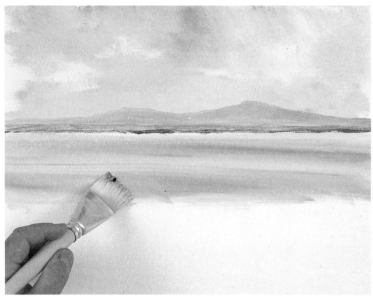

Adding a little bit more green, paint the sea closest to the bottom of the picture. This time use narrow horizontal strokes with the large brush.

Put your large brush back into the water and clean it.

Now, we are ready to paint the headland on the right of the picture, but first, let the sea dry.

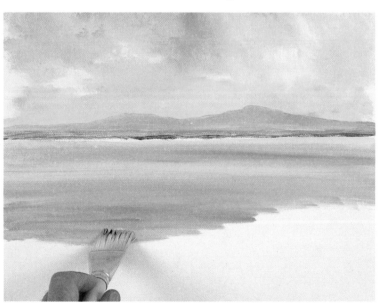

Headland

For the headland we use some Burnt Umber, Raw Sienna and a little bit of Phthalo Green, about 1/3 of each. Start at the right hand side of the painting and using the medium brush, paint the headland.

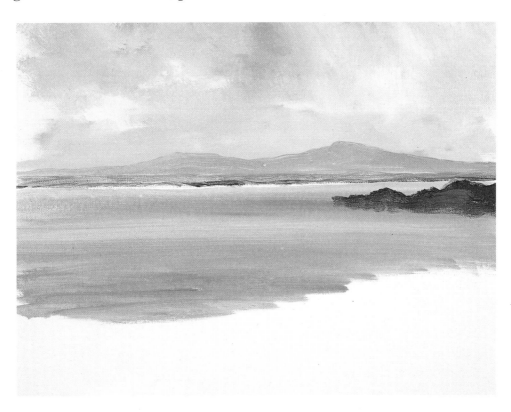

Each time you dip your brush into the paint, fill it with slightly different combinations of these colours and it will give you the effect of rocks.

You should be able to see the brush strokes on the headland. Don't try to get rid of the brush strokes or you will spoil it.

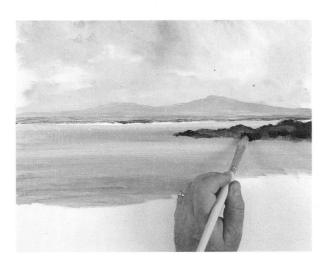
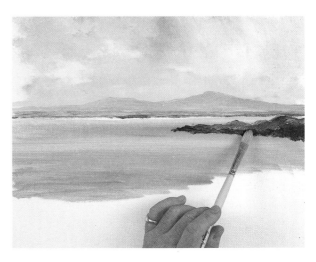

The Beach

Let's paint the beach in the foreground. This is a light colour and for this you need some Raw Sienna and Titanium White, about 25% Raw Sienna and 75% Titanium White. If you find the area where you are mixing your white paint becomes muddy, just put out some more Titanium White on a clean part of the palette.

Using the large brush, paint the beach in the foreground, making sure you sweep the beach from right to left. If you need to paint over some of the sea, just make sure the sea is dry first. So you see, you can't make a mistake.

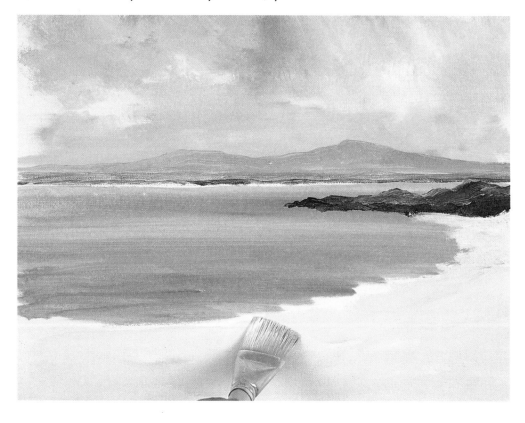

Add a little bit of Burnt Umber to create shadows on the beach, as you did in the first lesson. Put your large brush back into the water and clean it thoroughly.

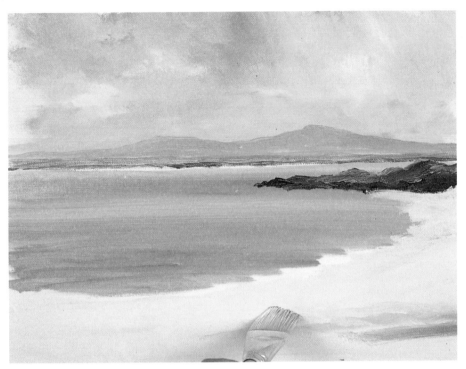

Now, dry the beach before you paint the rocks. The great advantage of acrylics is that, because you can dry one colour before you add more paint on top, you can layer paints one on top of another, without getting MUD.

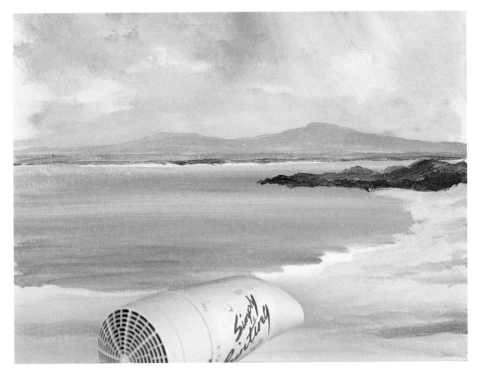

Using 20% Titanium White, 40% Ultramarine Blue and 40% Burnt Umber, let's make a colour for the rocks. Use the medium brush and start painting the rocks on the right hand side of the foreground.

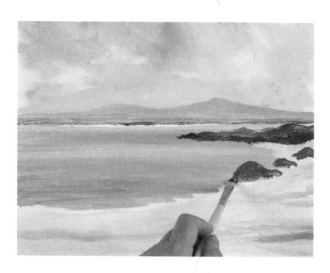 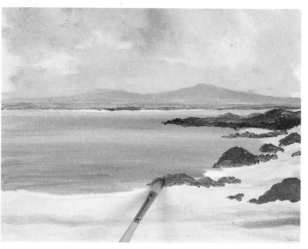

Now, paint the large rock on the left hand side of the beach. Don't be afraid to put in the rocks, if you don't like them, you can change them.

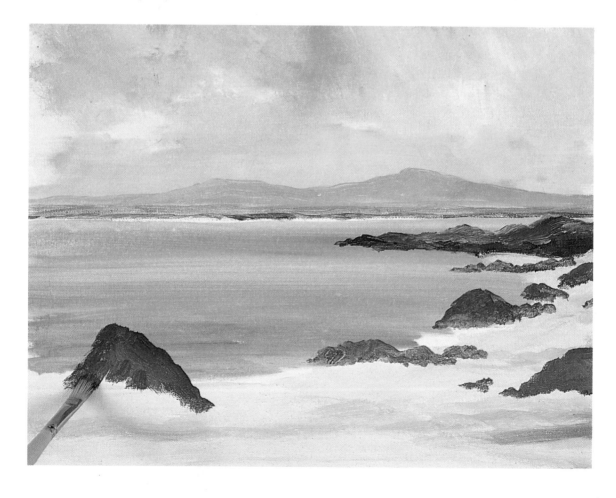

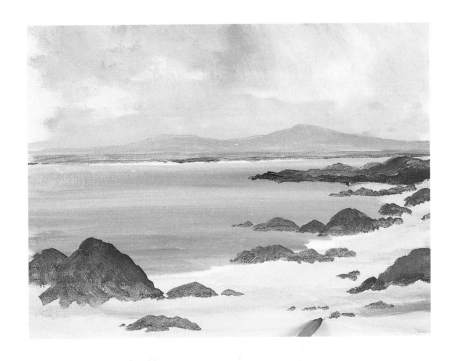

Once you outline the rocks you can lighten and darken them.

To make the rocks darker, add a little more Ultramarine Blue and Burnt Umber, to make them lighter, add in some more Titanium White.

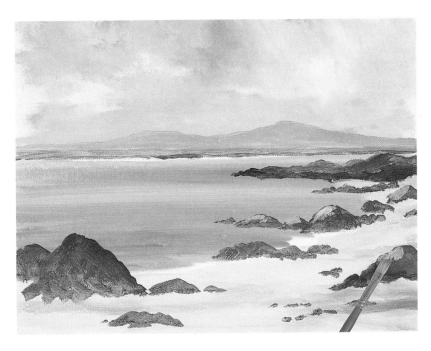

Now you must decide which side of the rocks are light and which side of the rocks are dark. This indicates where the sun is coming from. In this case, the sun is on the left hand side, as the sun sets in the west.

So, using the medium brush with some Titanium White, paint some light areas on the left hand side of the rocks - this gives the rocks their highlights.

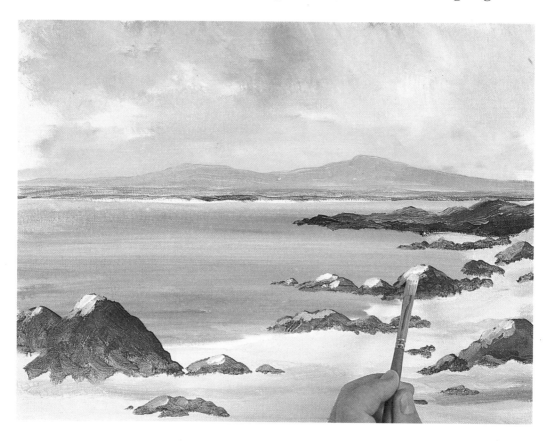

Put your brush back into the water and clean it.

Put some Cadmium Yellow Pale Hue on the palette and, using the medium brush with 75% Cadmium Yellow Pale Hue and 25% Ultramarine Blue, add a little green to the headland on the right hand side.

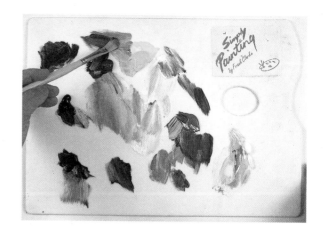

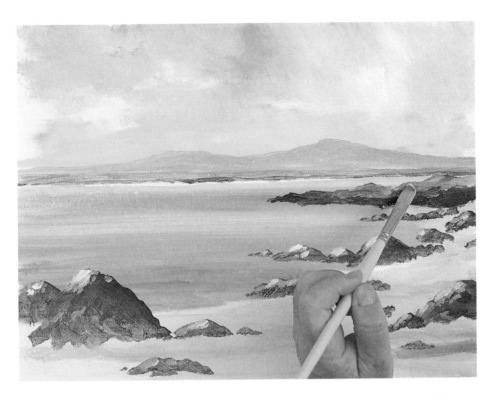

Now, let's add some finishing touches to the sea. Clean your brush and dry it on the cloth. Using the medium brush and Titanium White only, paint between the headland and sea on the right hand side.

Look at the finished painting to get an idea of where to put in the white. This gives the effect of waves breaking on the rocks.

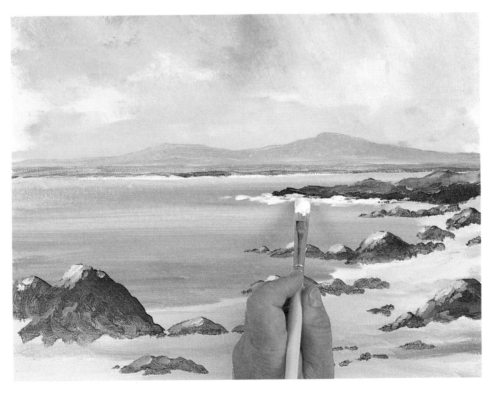

Next, to create some waves breaking on the shore, take the medium brush with some Titanium White and use narrow horizontal strokes to paint in some waves.

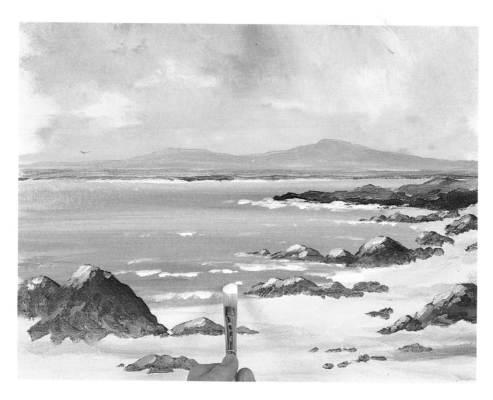

TIP: Look at the direction of the waves before painting them

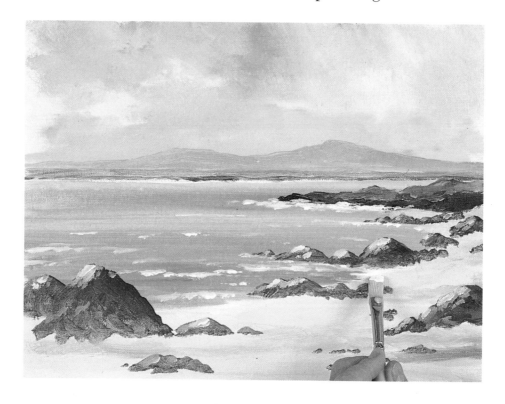

Now, while I was painting, there was a man fishing off the headland. So, let's paint him now. Remember figures are easy if you do them my way and think carrots not people. Using the small brush and some Vermilion Hue, paint a half carrot at the end of the headland.

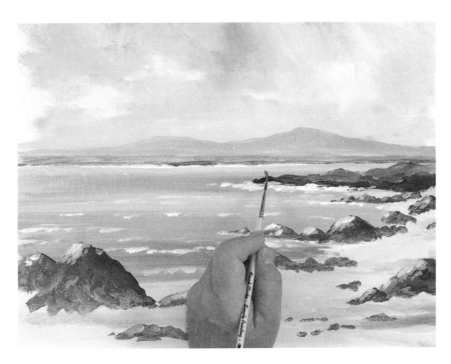

With the small brush and some Burnt Umber, put the head a little to the left of the carrot, to make it look as though he is leaning forward fishing. Don't make the head too big. Finally, add in a little fishing rod.

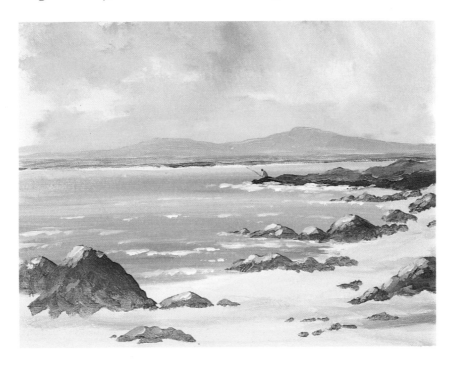

Now let's paint the boats. The little boats are painted using the small brush with Titanium White paint only. Paint a couple of strokes downwards and this will act as the sail.

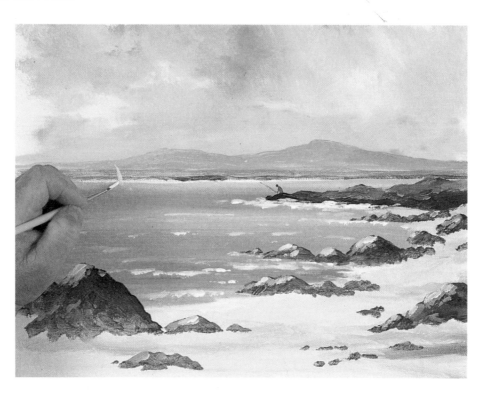

Now to paint the body of a boat, using the small brush, just add a little bit of Burnt Umber and put a tiny stoke underneath the sail.

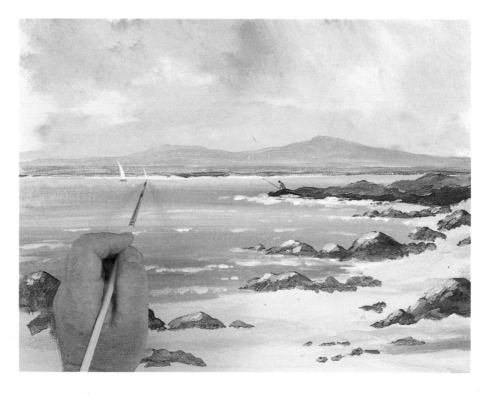

Lastly, all we have to do is add our little birds using Burnt Umber with the small brush paint the letter "V".

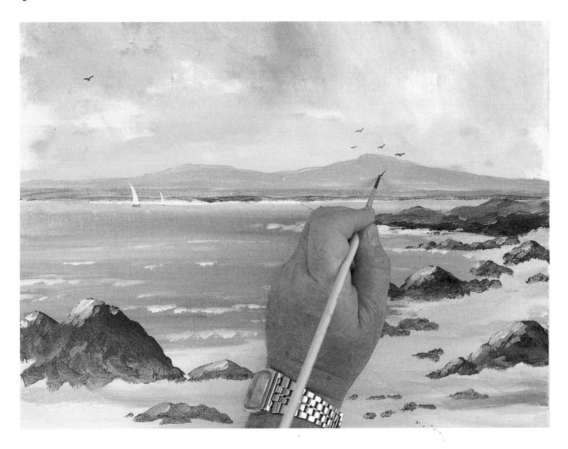

Now sign it.

Well Done!

Another masterpiece completed.

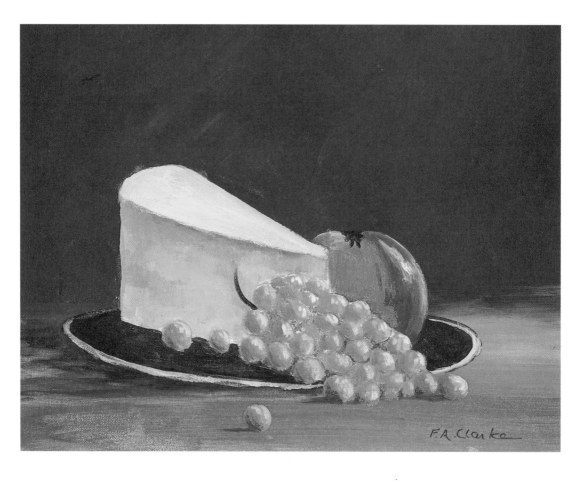

Still Life with Cheese, Apple and Grapes

FOR THIS LESSON YOU WILL NEED THE FOLLOWING MATERIALS
14" x 10" (35.5CM x 24.5CM) WINSOR CANVAS BOARD
1.5" (38MM) *Simply Painting* LARGE ACRYLIC BRUSH
Simply Painting MEDIUM ACRYLIC BRUSH
Simply Painting ROUND ACRYLIC BRUSH
Simply Painting PALETTE OR A LARGE WHITE PLATE OR TRAY.
WATER CONTAINER • OLD CLOTHS • A PENCIL AND A RULER
A SHEET OF PAPER
AN EASEL AND A HAIRDRYER, IF YOU HAVE THEM

ACRYLIC PAINTS
TITANIUM WHITE • CADMIUM YELLOW PALE HUE
RAW SIENNA • ULTRAMARINE BLUE • BURNT UMBER
VERMILION HUE • PHTHALO GREEN

8: Still Life with Cheese, Apple and Grapes

Painting is a wonderful gift, it's great fun and you can enjoy it immensely whatever the weather. You don't have to be outdoors to paint, you can always set up your own still life in your studio.

I painted the next picture after Peg and I visited our good friend Brian Hughes at the Abbey Glen Hotel in Clifden, Connemara. We had a wonderful dinner there and finished in front of a turf fire with grapes, cheese, apples and indeed wine. When we returned to my studio I got the bits and pieces together to paint my own still life. Now I am going to show you how to paint it by applying the **Simply Painting, Have Some More Fun** method.

When you look at the finished painting, you will see there is a piece of cheese, an apple and some grapes on a plate. You may never have painted these objects before, but don't be afraid, just simplify them.

This is easy because they are made up of the following simple shapes, a triangle, a rectangle, a large circle, an oval and some small circles. So let's see how they are drawn.

To begin, try them out on a piece of paper with your pencil. First the cheese, how do you draw that? Well, start by drawing a rectangle and on top of the rectangle, draw a triangle with the right hand side longer than the left, and that gives us our cheese.

Next, how do you draw an apple? An apple is only a freehand circle and the grapes, if you look at them, are only smaller circles drawn freehand.

The plate is only a disc flattened.

So, if you take these elements and put them together, you can draw all the shapes we have in our still life.

TIP: If you are going to paint a still life, break it down and simplify it. Now, let's start with *Have Some More Fun* and draw the horizon line.

Step 1: Have - Horizon Line

Set the canvas board up on its long edge, as we will paint this picture in landscape fashion. Draw the horizon line about 4" up from the bottom using a pencil and your ruler.

Now, using the pencil, draw the piece of cheese just as you practised. Let the cheese break the horizon line. Don't worry if you make a mistake, as you can just rub it out and start again. Next draw the apple. You can if you like overlap the apple on the cheese - it's your apple and the overlap will not be seen when it is painted over.

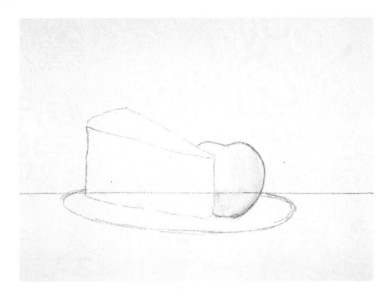

Let's draw the plate which is below the horizon line. Draw it as a disc or an oval.

Finally, draw the grapes on the plate.

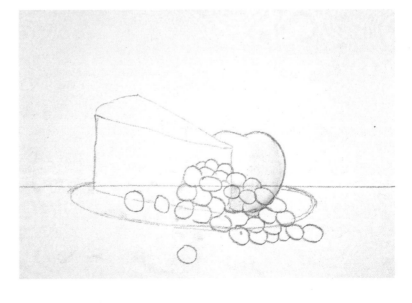

Step 2: Some - Sky

Background

Now let's paint the sky, which is the background in this painting. We need a rich dark colour, so put out some Vermilion Hue, Ultramarine Blue and Burnt Umber on the edge of your palette.

Take some Vermilion Hue and Ultramarine Blue to the centre of the palette and add a little bit of Burnt Umber. In this case the proportions are 20% Burnt Umber, 40% Ultramarine Blue and 40% Vermilion Hue.

Take your large brush from the water, dry it on the cloth and scumble the paint onto the canvas board (see Brush Strokes Chapter 3). It doesn't have to be even, allow your paint to mix on the canvas board, rather than on the palette. If you happen to paint over the cheese you have drawn on the canvas board, it will not matter.

The background is often be the hardest part to paint because it can be very boring.

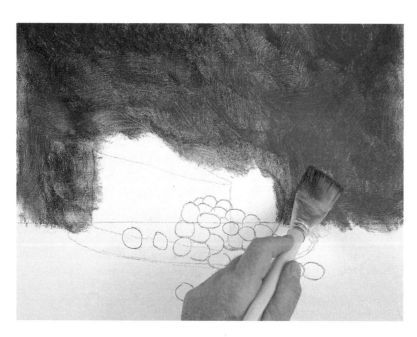

Long ago many artists had students who painted the background and then the masters would come along and add the finishing touches to the painting - and charge accordingly.

Paint the background down to the horizon line.

68

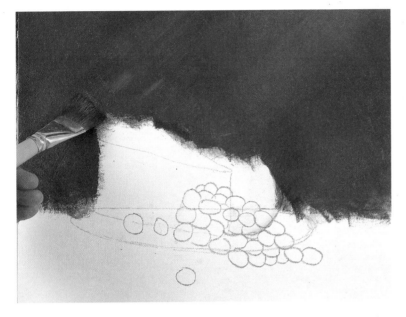

You may need to give the background a second coat, if you do, make sure you dry the first coat **before** applying the second coat.

Paint the background a little darker on the left hand side by using more Burnt Umber.

Put your large brush back into the water and clean it. Now put some Raw Sienna and Cadmium Yellow Pale Hue on the edge of your palette.

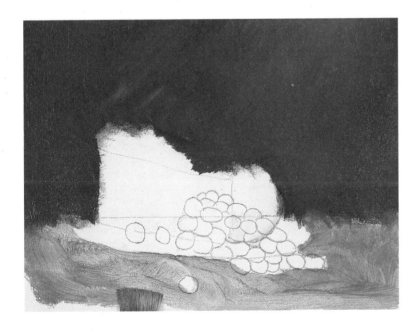

Now, taking 75% Raw Sienna and 25% Vermilion Hue on the large brush, paint the background below the horizon line.

Again, it may be necessary to give it more than one coat. Paint the background a little darker on the left hand side using more Burnt Umber and the large brush. This will create a nice shadow for the cheese.

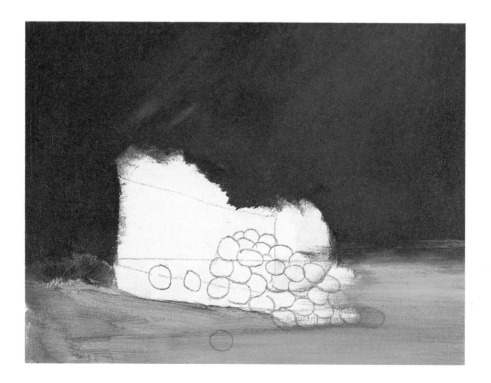

When you finish, dry the painting. As it dries you will see the paint turn matt and lose its shine. You can use a hairdryer or wait until it is dry. Why not have a cup of coffee.

There is a time in every picture when you wonder what on earth you are doing, you probably feel like that at the moment but don't despair.

When you are finished, put your large brush back into the water and clean it thoroughly.

Step 3: More - Middleground

Cheese, Apple & Grapes

Now we are ready to paint the cheese, apple, plate and grapes. So put out some more Titanium White at the edge of your palette. Take your medium brush from the water and dry it on the cloth.

Using 50% Titanium White and 50% Cadmium Yellow Pale Hue, with a tiny amount of Vermilion Hue, paint the top and the side of the cheese.

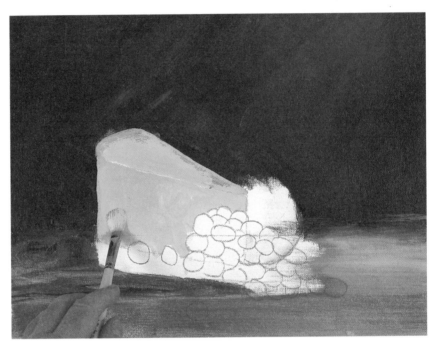

When you have painted the cheese with this colour add a little bit more Vermilion Hue, which will create a darker tone for the side of the cheese.

If you want to darken the side of it a little bit more, do so with another tiny amount of Vermilion Hue. Put your medium brush back into the water and clean it.

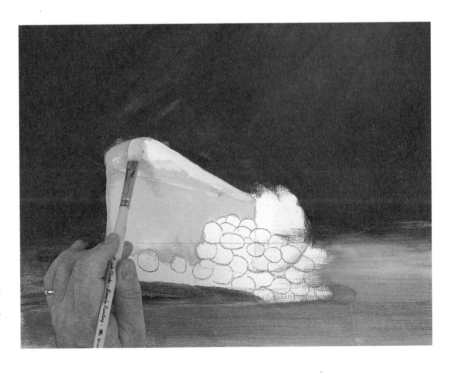

Using Titanium White and Cadmium Yellow Pale Hue, 50% of each, paint the top of the cheese.

Now we want to darken the top edge at the side of the cheese a little bit mor[e]. To do that, just add a little bit of Vermilion Hue and it will create a darker to[ne] for the top edge of the cheese.

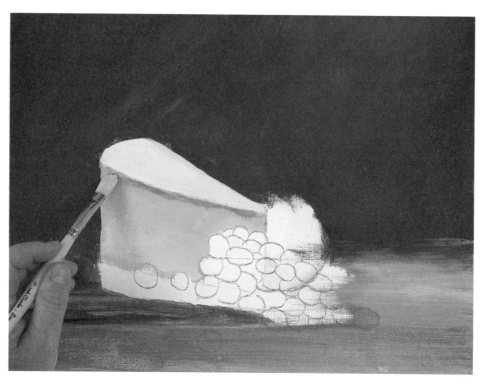

Clean the medium brush and dry it on the cloth. Next paint the plate with [a] mix of 50% Burnt Umber and 50% Ultramarine Blue.

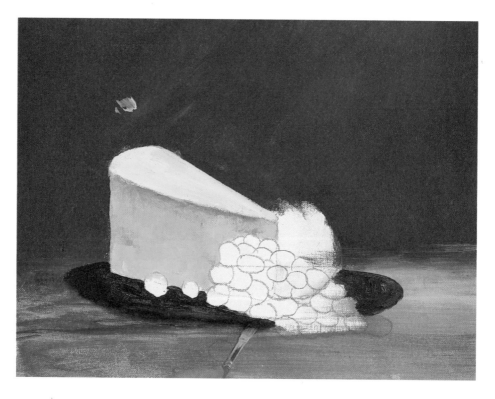

Let's paint the apple (the large circle). To do this you need to put out some Phthalo Green at the edge of the palette.

Now take the medium brush from the water and mix equal amounts of Raw Sienna, Cadmium Yellow Pale Hue and Phthalo Green.

Paint the apple as it is shaped, drawing your brush around in a circle. Remember, don't mix your colours too much on the palette, let them mix on the canvas board and you will get better tones.

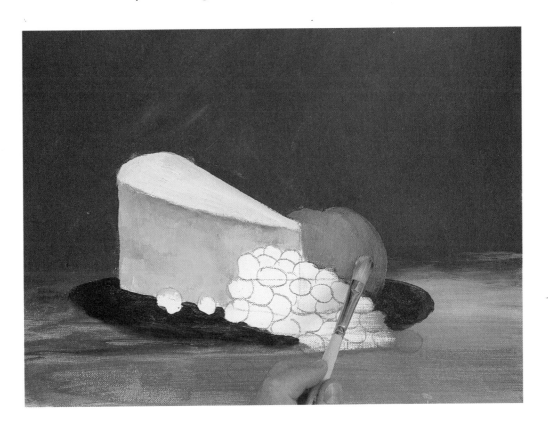

The grapes are painted with 75% Titanium White and 25% Phthalo Green. using the medium brush.

Paint the grapes around in a circle, but don't be too fussy if a little white from the canvas board shows through, as you will use this to create shadows between the grapes.

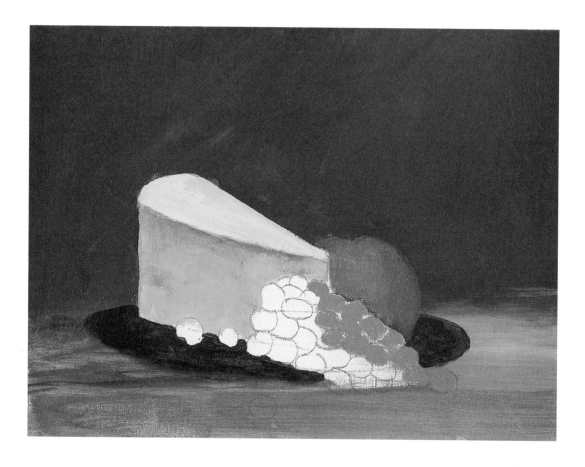

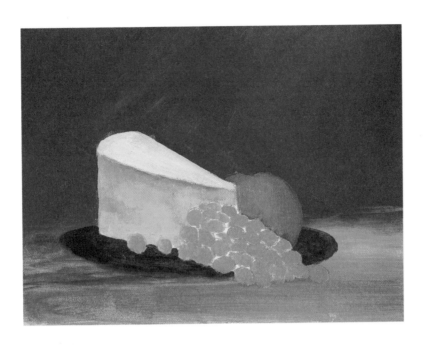

The shadows between the grapes are created using the small brush with Burnt Umber and Ultramarine Blue which gives us a dark shade.

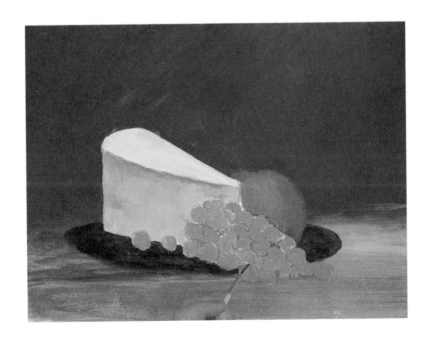

75

To give the grapes more shape, add some Raw Sienna and Phthalo Green on the left hand side of each grape.

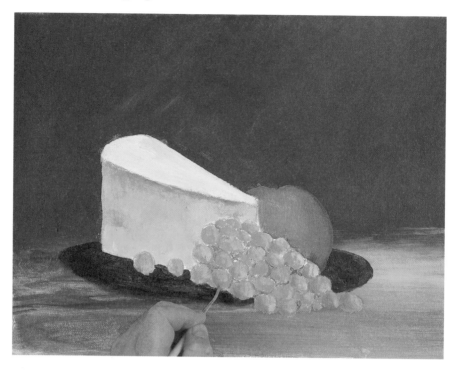

When you are finished painting the grapes with this colour, dip your brush into the water and clean it.

Take up some Titanium White with the small brush and paint some highlights on the right hand side of each grape.

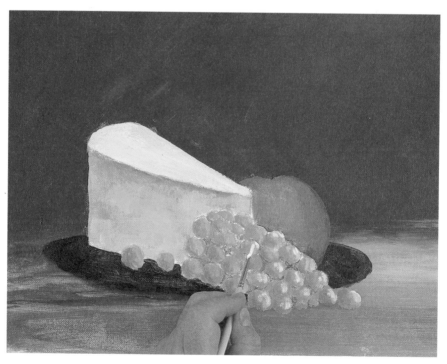

Next add in a little outline around the edge of the plate, using some Titanium White only and your small brush. Use your hairdryer to dry the painting or wait until it is dry before going any further.

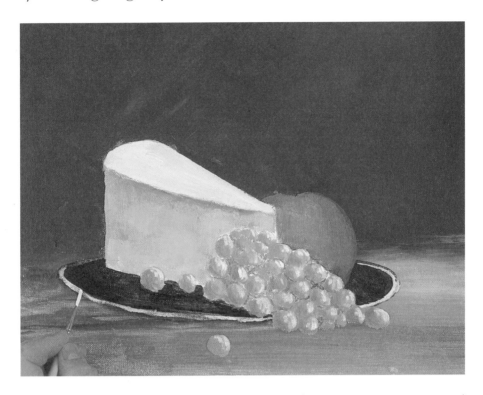

Use your small brush with a little bit of Vermilion Hue, to create the rosy hue on the right hand side of the apple. Clean your brush.

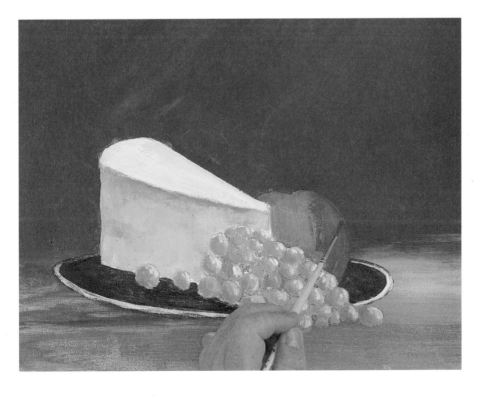

Paint a highlight on the right hand side of the apple using the medium brush with some Titanium White only. Put your medium brush back into the water and clean it.

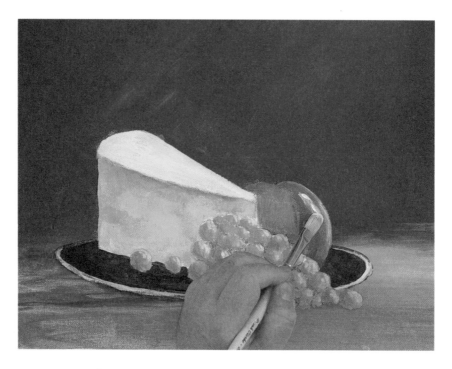

Now, using the small brush with Burnt Umber only, paint the dark detail in the centre on the top of the apple. Also, paint a stalk on the left hand side of the bunch of grapes.

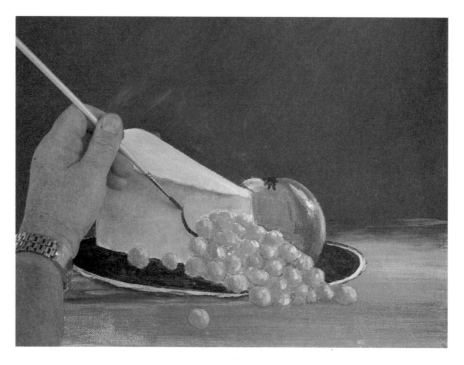

Before you finish add a shadow with a little Burnt Umber and the small brush, to the left hand side of the single grape and the other grapes at the bottom of the plate.

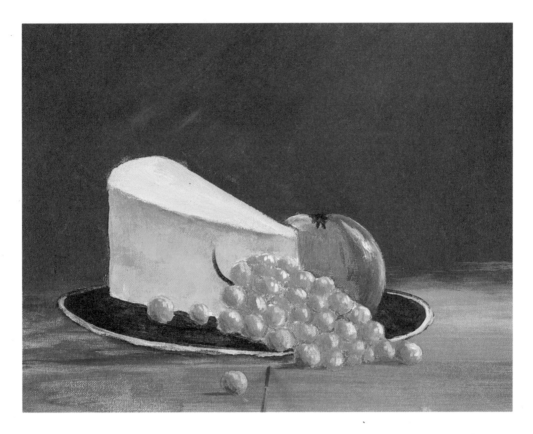

Now, the last thing I do is put in my little bird, you don't have to, but you can if you wish.

Finally, sign your painting and make sure you clean your brushes when you are finished

TIP: Don't give your pictures away, sell them, they will pay for your materials.

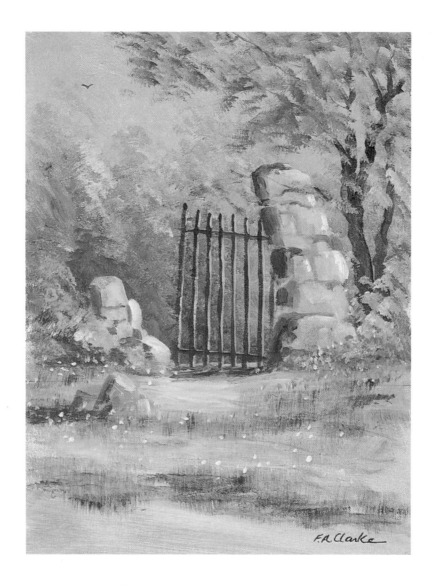

Gateway at Errislannan

FOR THIS LESSON YOU WILL NEED THE FOLLOWING MATERIALS
14" x 10" (35.5CM x 24.5CM) WINSOR CANVAS BOARD
1.5" (38MM) *Simply Painting* LARGE ACRYLIC BRUSH
Simply Painting MEDIUM ACRYLIC BRUSH
Simply Painting ROUND ACRYLIC BRUSH
Simply Painting PALETTE OR A LARGE WHITE PLATE OR TRAY.
WATER CONTAINER • OLD CLOTHS • A PENCIL AND A RULER
AN EASEL AND A HAIRDRYER, IF YOU HAVE THEM.

ACRYLIC PAINTS
TITANIUM WHITE • CADMIUM YELLOW PALE HUE • PHTHALO GREEN
ULTRAMARINE BLUE • BURNT UMBER • PERMANENT ROSE • RAW SIENNA

80

9: Gateway at Errislannan

This is a painting of a gateway at Errislannan. It's not the main entrance to the house but one of the side gates. It was made by a famous ironworker from Clifden and I particularly liked the way the pillar was falling down.

Clifden's setting is magnificent, with the Twelve Bens rising in the east to their highest point at Benbaun. It is often known as the capital of Connemara and has sandy beaches within a mile. From the air the ground looks more solid and level than it is, a fact which fooled Alcock and Brown as they landed with the nose of their plane stuck in the bog at the end of the first transatlantic flight in 1919.

Before starting to paint, look at the finished painting. The horizon line is below the old gate. The middleground is made up of the gate, the pillars, the tree and the small rock. Finally, the foreground is the roadway. But, there is something I want to tell you. These were not the exact colours I saw on the day. The sky was blue not pink, and what I did, was choose colours which I felt gave a pleasing background.

In fact, I have often been asked to paint pictures to suit people's wallpaper and curtains - but such is the life of an artist, and it can be all the more fun, as it gives us a chance to use all our favourite colours.

Step 1: Have - Horizon

This time, place the canvas board upright on the easel, that is, in portrait fashion. Again we will paint this picture using the *Have Some More Fun* method - Horizon, Sky, Middleground and Foreground.

First of all, draw the horizon line which is about 5" from the bottom of the canvas board - fairly high, but not quite half way up the canvas board.

81

Step 2: Some - Sky

Now, let's paint the sky. Put out some Titanium White, Raw Sienna, Permanent Rose and Ultramarine Blue.

I generally put the paints in the same position on the edge of the palette because I always know where they are. Painting can be a bit like playing the piano, you don't want to shift the keys around while you are playing.

Take your large brush from the water and dry it on the cloth.

For this sky, take some Titanium White to the centre of the canvas board and add a little Ultramarine Blue - about 90% Titanium White and 10% Ultramarine Blue.

Use this mixture to paint the sky. Do it very quickly, using scumbling strokes (see Brush Strokes Chapter 3).

Now, using a little Titanium White, Raw Sienna and Permanent Rose, equal amounts of each, make a pink colour to paint on some of the sky.

Don't paint the sky too even, use short scumbling strokes and paint it very quickly. You can really use any of these colours to paint the sky, it depends on what you like yourself.

Now, put out some Cadmium Yellow Pale Hue on the palette. Add a little bit of Cadmium Yellow Pale Hue and Permanent Rose to the paint on the centre of the palette.

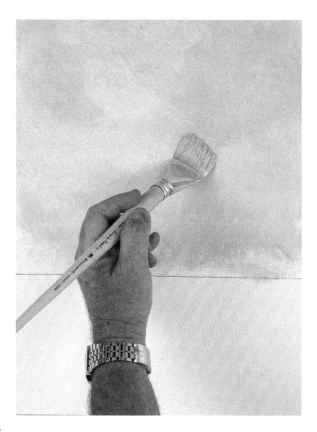

Use this to add some more tones to the sky. This is the yellowish/pinkish colour we are looking for.

Rather than leaving brush strokes on the canvas board and to soften the sky, run the large brush lightly over the entire sky. Don't worry if the sky is not exactly the same as the finished picture.

Step 3: More - Middleground

Now we are ready to paint the bushes. For this, you need a green which is made using 60% Cadmium Yellow Pale Hue, 20% Ultramarine Blue and 20% Raw Sienna.

If you are not happy with this mixture, you can adjust it to your own liking.

Tip: Always work from the background towards the front. You wouldn't paint the gate and then try to paint around it.

Use the corner of the brush to dab the green into the centre of the background and down to the horizon line. If it's too dark, lighten it, by adding more Cadmium Yellow Pale Hue and a little Titanium White.

Behind the gate is a little darker, so just add a little bit of Ultramarine Blue to your colour and paint the centre of the background where we are going to paint the gate.

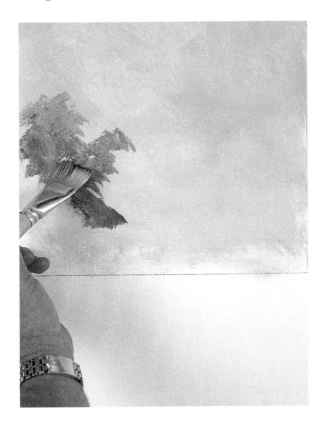
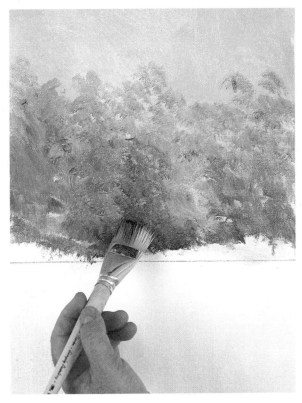

Use some lighter green to paint the top of the trees, by adding more Cadmium Yellow Pale Hue to the mixture on your palette.

When you are finished put your large brush back into the water and clean it.

Now let the painting dry, or use your hairdryer, before moving on.

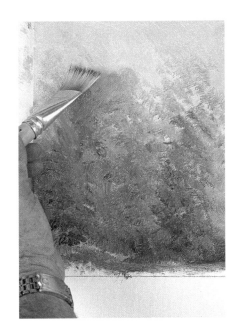

Take your medium brush from the water and dry it on the cloth. Now, let's paint the large pillar. Using some Burnt Umber, Raw Sienna, Ultramarine Blue and a little bit of Titanium White, outline the pillar on the canvas board. The pillar is leaning to the left, so paint it that way.

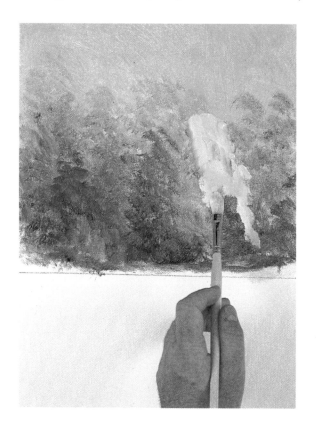 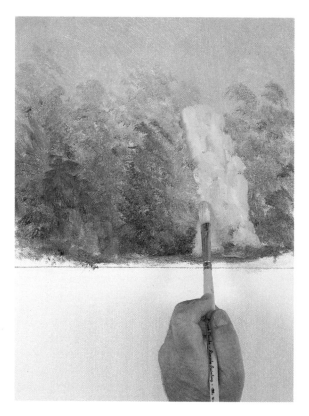

As the left hand side of the pillar is in shadow, add a little bit of extra Burnt Umber and just paint some strokes down along the left edge of the pillar.

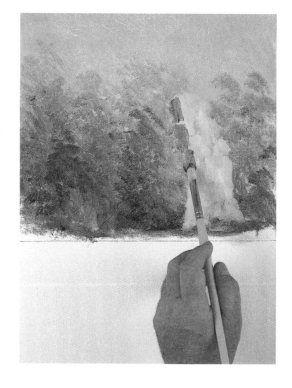

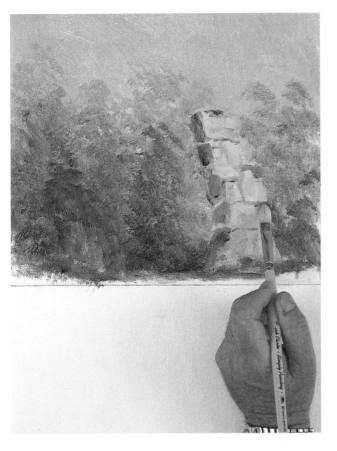

Using the medium brush and some inky paint, made up of Burnt Umber with a tiny amount of Ultramarine Blue, paint the gaps between the rocks on the pillar. The pillar is made of old stones laid on top of one another. Don't overdo it.

Put your medium brush back in the water and clean it.

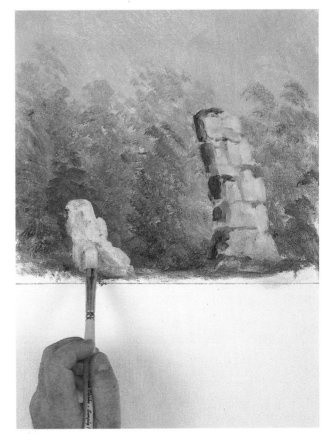

Now paint the small pillar using the same mixture you used for the large pillar. I like to paint the pillar first using light paint, then darken it, and finally paint some highlights.

Step 4: Fun - Foreground

Take your large brush from the water and dry it on the cloth. Using 20% Titanium White, 60% Cadmium Yellow Pale Hue, 10% Phthalo Green and 10% Ultramarine Blue, paint the foreground down as far as the roadway. Keep the colour light.

You will need lots of paint for this area, but every time you take paint from your palette, pick up different combinations of these colours. This will create shadows and highlights in the foreground. While the paint is still wet, add a little Titanium White between the two pillars.

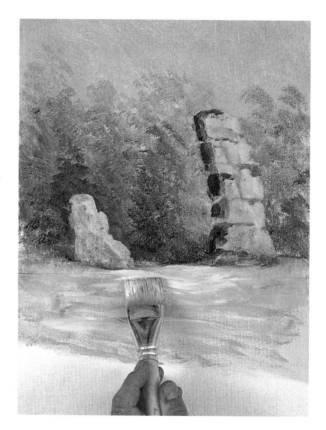

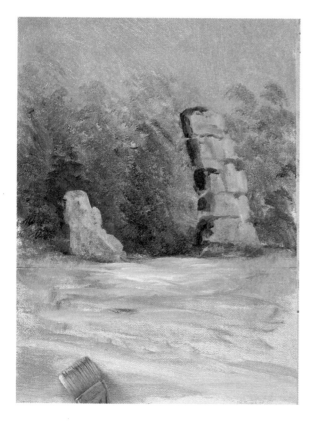

Now we are ready to paint the roadway. Use the large brush with 80% Titanium White, 10% Burnt Umber and 10% Ultramarine Blue to paint the roadway. When you are finished return your large brush to the water.

Next paint the tree on the right hand side of the picture using Burnt Umber with the small brush. Start from the ground up and don't paint the tree too straight. Gradually lift your brush off the canvas board as you move up and this will give you the effect of branches which thin out as the tree becomes taller. When you are finished clean your small brush in the water and put it aside.

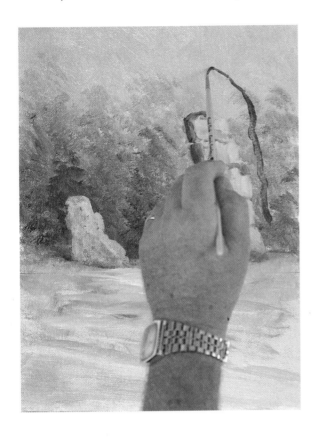

You have now completed the skeleton of the tree. Let's put some highlights on the bushes on the left hand side of the picture.

So take some Titanium White to the centre of the palette and add some Cadmium Yellow Pale Hue.

Take the large brush from the water and dry it on the cloth. Use a dabbing stroke with the corner of the brush, to paint around the tops of the bushes.

This gives the effect of sunlight in the trees.

Use the same mixture to paint the bushes at the bottom of the tree on the right hand side of the large pillar and on the left hand side of the small pillar.

Now before we add some highlights and some shadows to the pillars. Return your large brush to the water and clean it.

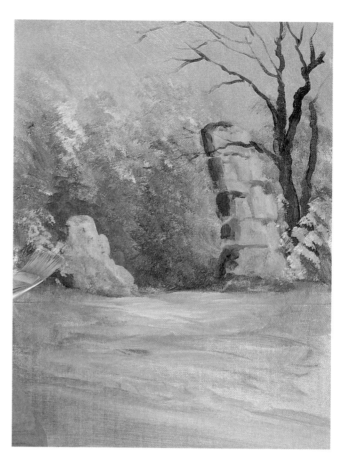

Take the medium brush from the water and dry it on the cloth.

Using some Titanium White only, paint some highlights on the right hand side of the small and large pillars.

Now clean your brush and using Burnt Umber only, paint some shadows on the left hand side of the small pillar.

Next outline the rock in the foreground using your medium brush and the same grey colour you used for the pillars. Add some highlights to the right hand side using Titanium White only and some shadows to the left hand side using Burnt Umber.

Clean the medium brush and, using some Burnt Umber only, paint a shadow on the ground below the large pillar. Paint another shadow on the ground to the left of the rock.

Return the medium brush to the water and clean it.

Now, take your large brush from the water and dry it on the cloth. Paint the leaves on the tree, using a mixture of Cadmium Yellow Pale Hue, Ultramarine Blue and Raw Sienna 1/3 of each.

Use the corner of the brush to dab the paint on and let the paint mix on the canvas board, not on the palette.

Now, paint some light tones on the tree using Titanium White and Cadmium Yellow Pale Hue.

When you are finished put your large brush back into the water and clean it.

Now you are ready to paint the old iron gate. Use the small brush like a pen, with Burnt Umber and Ultramarine Blue. Make the paint very inky by using more water. Paint the top and bottom cross bars first.

Starting from the top of each bar, paint downwards. Don't draw the gate with a ruler, in fact a shaky hand will make it look even better.

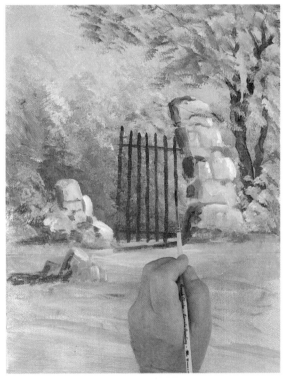

Now, put your brush back into the water and clean it.

To give the bars of the gate more shape, take some Titanium White on the small brush and paint the right hand side of each bar.

Tip: Remember, they will look much better if you don't paint them too perfect.

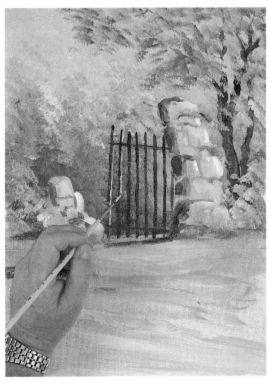

93

Now, using 50% Burnt Umber and 50% Raw Sienna, with downward strokes of the large brush, paint the grass in the middleground, below the large pillar. Add some more Burnt Umber and do the same at the edge of the road. Return your brush to the water.

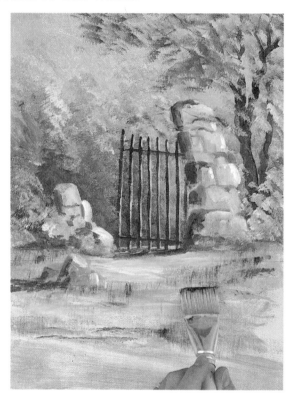 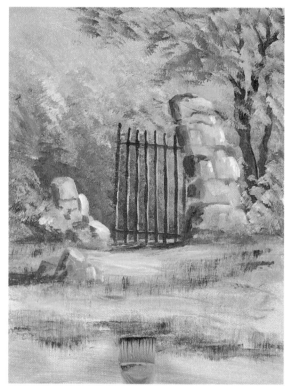

Let's paint the flowers, bluebells in this case, around the bottom of the tree.

Use the small brush, with Titanium White and Ultramarine Blue, to dab in a few bluebells at the base of the large pillar.

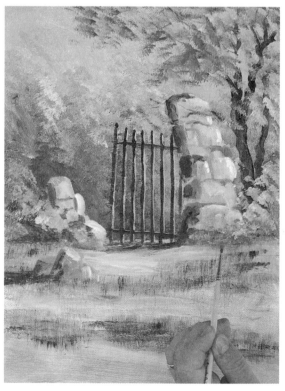

Next, using the small brush with Titanium White only, make a few dabs in the foreground to create small daisies.

If you want you can put in some dandelions, using Cadmium Yellow Pale Hue only, be my guest.

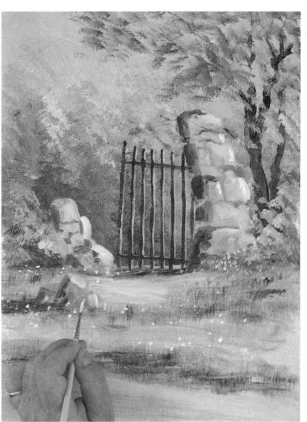

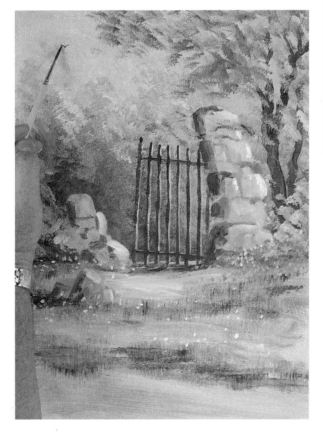

Using only Burnt Umber, paint the bird in the top left hand corner.

Now all that is left to do is to sign it.

Well done!

95

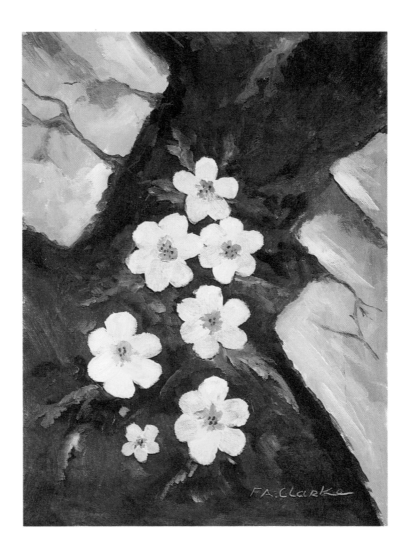

Burren Flowers

FOR THIS LESSON YOU WILL NEED THE FOLLOWING MATERIALS
14" x 10" (35.5CM x 24.5CM) WINSOR CANVAS BOARD
1.5" (38MM) *Simply Painting* LARGE ACRYLIC BRUSH
Simply Painting MEDIUM ACRYLIC BRUSH
Simply Painting ROUND ACRYLIC BRUSH
Simply Painting PALETTE OR A LARGE WHITE PLATE OR TRAY
WATER CONTAINER • OLD CLOTHS • A PENCIL AND A RULER
AN EASEL AND A HAIRDRYER, IF YOU HAVE THEM.

ACRYLIC PAINTS
TITANIUM WHITE • CADMIUM YELLOW PALE HUE • PHTHALO GREEN
ULTRAMARINE BLUE • BURNT UMBER • PERMANENT ROSE • RAW SIENNA
VERMILION HUE

10: Burren Flowers

The Burren in County Clare, Ireland, is an incredibly beautiful place. It is one of the strangest and loneliest places in Ireland. It is an ancient landscape of bare limestone originating from the Ice Age which shelters some of Ireland's rarest flowers. For anyone who has an interest in wild flowers or in painting wild flowers I know of no better place to visit. In my travels around the Burren, I discovered many beautiful things and, in this lesson, I am going to show how to paint some buttercups I found there, in a crevice, between the rocks.

Step 1: Have - Horizon

First of all, put your canvas board on the easel standing on one of its short edges. We are going to paint in portrait fashion. **Have Some More Fun,** means Horizon, Sky, Middleground and Foreground and it applies whether we are painting a landscape or flowers.

First look at the finished picture and read the lesson in full before starting to paint. What you see are some little buttercups growing in a crevice between the rocks. An unusual aspect of this picture is the colour between the rocks, I made it a rich purplish, reddish colour. So, if you have all the materials ready, let's start.

First of all, let's draw the horizon line. Using a pencil and your ruler, draw the horizon line straight across the board about nine inches from the bottom of the canvas board.

Put some Ultramarine Blue out on the edge of the palette. Now, using the small brush, with some Ultramarine Blue, make it the consistency of ink, and map in the rocks. Starting with the rock on the top left hand side, draw your brush down the canvas board, stopping just above the horizon line, and then curling back to the edge of the board.

Next, using some more inky Ultramarine Blue, outline the edge of the rock on the right hand side of the canvas board. Have a good look at the rocks before you draw them and if you make a mistake, don't worry, you can draw them again. The outlines will be covered later.

Now, dip your brush into the water and rinse it out. When it is clean, take it out of the water and leave it to one side. The reason I don't leave this small brush in the water is that the nylon hairs are very fragile and can bend if you leave the brush in water. However this does not apply to the other brushes.

Step 2: Some - Sky

Now let's paint the background and for this you need three colours, Ultramarine Blue, Permanent Rose and Raw Sienna.

So put out Permanent Rose and Raw Sienna on the side of the palette. Next take the large brush from the water and dry it on the cloth.

Drag some Permanent Rose, Ultramarine Blue and Raw Sienna to the centre of the palette, about 1/3 of each will do.

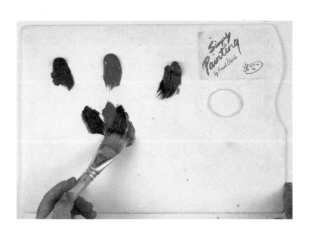

98

Starting from the top and working down, use these colours to paint the crevice between the two rocks.

You can adjust the colour to your own taste, either lighten it or darken as you please.

To give the background a mottled look put some red directly on the canvas board with some blue and brown beside it, then mix the paints together on the canvas board.

Continue to paint down towards the bottom of the canvas board using as much paint as you require. Now dry it using the hair dryer.

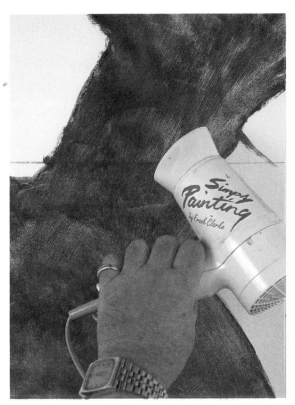

The great advantage of acrylic paints is that we can dry them very quickly. You cannot do this with oils - you would have to wait days before you put on your next coat. As it dries, it will begin to go matt and lose its shine. If you don't have a hairdryer you can wait about 20 minutes or so for the background to dry before applying the second coat.

Now using the same three colours, paint over the background again, exactly as you did before - you will find it a lot easier this time.

When you have finished the background, put your large brush into the water and clean it.

Step 3: More - Middleground

Now to paint the rocks you need to put out some Titanium White on the side of the palette. Then take the medium brush from the water and using Raw Sienna with some of the colour you mixed for the background, which is on the centre of your palette, paint a first coat on the rocks. Don't make the colour too dark, use plenty of Titanium White in the mix.

Start by painting the rock on the right hand side of the canvas board and then the one on the left hand side. Leave some brush strokes showing.

Now add a little more Ultramarine Blue to this mix, and paint some shadows on the rocks.

When you are finished, return the medium brush to the water and cleanit.

Now let's give the rocks some depth by painting some shadows around their edges. For this put some Burnt Umber on the edge of the palette.

With the medium brush and a mixture of Ultramarine Blue and Burnt Umber, 1/2 of each, create these shadows by painting some of this colour around the outside edge of the rock on top of the background colour.

Paint all around the rock on the left.

However, for the rock on the right, look carefully at the picture to see where the shadows are. You will notice they are only in a few places on the left of that rock.

At this stage, the rocks are still very flat looking, so let's put some cracks into them. We do this by mixing some inky Burnt Umber and painting some cracks on the rocks with the medium brush. This will give more life to the rocks. When you are finished clean your brush and using some Titanium White only, paint some highlights on the rocks.

Now we come to the flowers. First make sure the background is dry. Put out some Cadmium Yellow Pale Hue on the palette.

Take the medium brush from the water and dry it on the cloth. Dip it into the Cadmium Yellow Pale Hue and add a little Titanium White, about 10% Titanium White and 90% Cadmium Yellow Pale Hue.

Tip: Before you start to paint the flowers use your pencil to mark each flower's centre on the canvas board.

Paint the petals of the flower, by starting at the outside edge. This is where the filbert brush is important, as it creates nice round petals. Just rest the brush on the canvas and drag it towards the centre of the flower. Don't be afraid to make a definite stroke, if you make a mistake, you can always go over it.

Paint all the flowers, starting with the one at the top and working downwards.

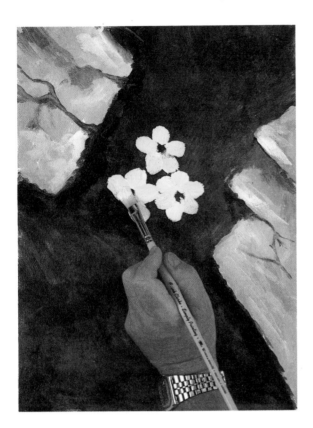 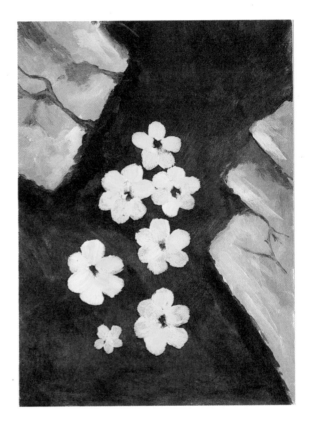

Don't mix your paint on the palette too much and remember not to make them the same size.

When you are finished painting the flowers, put your medium brush back in the water and clean it.

Next paint the centres of the flowers. To make this mix, put out some Vermilion Hue on the palette. Then mix 50% Vermilion Hue and 50% Cadmium Yellow Pale Hue together.

Use the small brush and dab it in the centre of each flower. Don't be too particular, it's only a dab of paint in the centre of each flower.

When you are finished clean the small brush and put it aside.

Next, we have got to put in some green leaves around the flowers. Put out some Phthalo Green on the edge of your palette. Take the medium brush out of the water and dry it on your cloth. Mix some Phthalo Green, Cadmium Yellow Pale Hue and Raw Sienna on the centre of the palette, about one third of each.

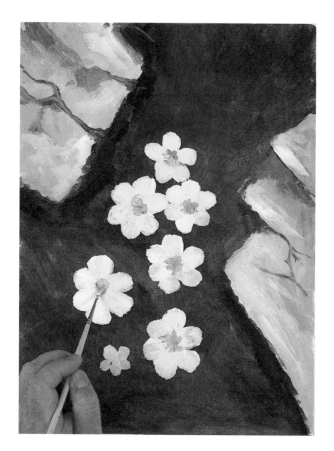

Paint the green leaves around the buttercups. Do not mix the colours too much on the palette, as we want to mix them on the canvas board. This creates some nice colouring around the buttercups.

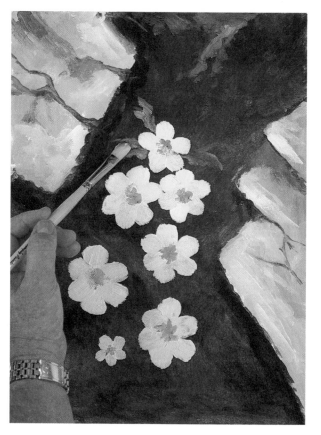

104

To darken this green, we can add a little bit of Ultramarine Blue and paint some around the flowers. This gives the effect of the flowers resting on the foliage.

You can also add a little bit of Cadmium Yellow Pale Hue to this colour, to create some highlights.

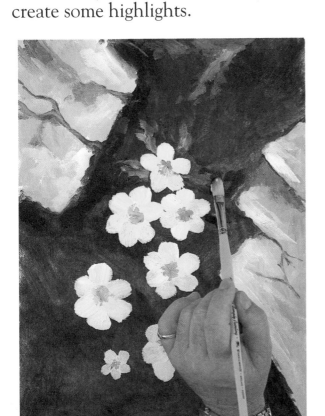 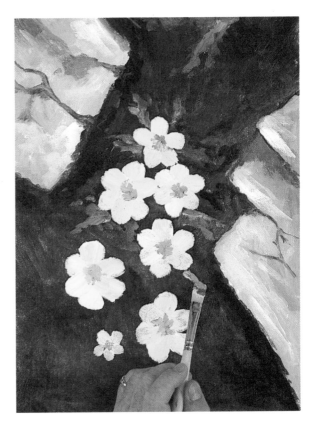

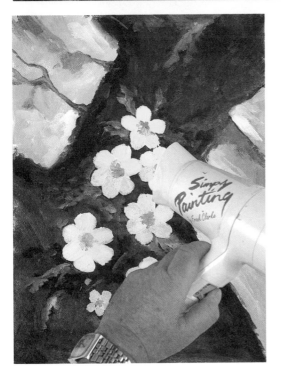

Clean your medium brush in the water and dry your painting.

Use your hairdryer if you have one, otherwise just let it dry naturally.

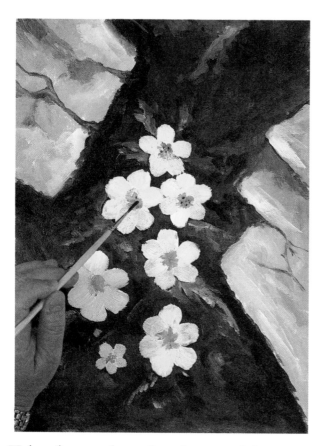

At the centre of each flower, are tiny speckles. Paint these using the small brush with some Burnt Umber and just dab little speckles in the centre of the flowers.

Make sure the centres are dry before you paint the speckles.

Now clean the small brush in the water and leave it aside.

Take the medium brush out of the water and dry it on the cloth.

Using Titanium White only, paint the edges of each flower. Make sure the petals are dry before you start to paint with the white and don't overdo it, just touch the tip of the brush to the outer edge of the petal.

When you are finished painting the petals with Titanium White, clean your medium brush in the water.

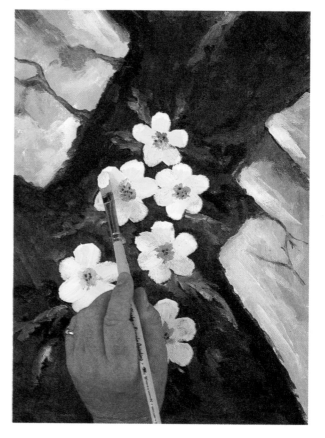

Finally, I always put in my little trade mark. This time I am going to paint the little bird in the background where he won't be noticed.

No doubt you will have no difficulty spotting him.

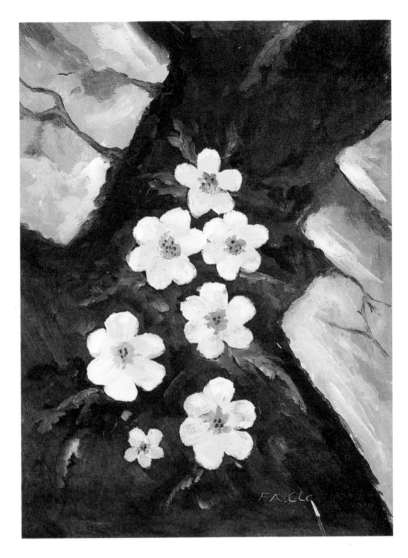

Clean your brush and sign your painting. You can use a pen or the small brush with some white paint. When you are finished clean all your brushes, dry them and put them aside.

Now, why don't you look around and find your own flowers to paint. Use the same background or vary the colours if you wish. You should be well able to paint them by now. Just remember, **_Have Some More Fun_** - Horizon, Sky, Middleground and Foreground.

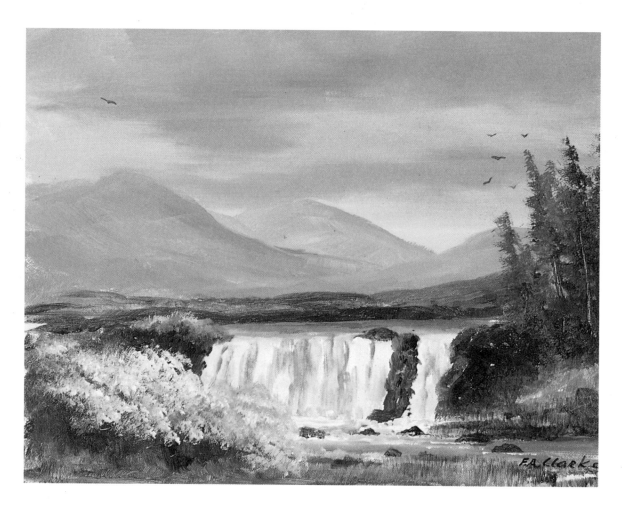

Aasleagh Falls

FOR THIS LESSON YOU WILL NEED THE FOLLOWING MATERIALS
14" x 10" (35.5CM x 24.5CM) WINSOR CANVAS BOARD
1.5" (38MM) *Simply Painting* LARGE ACRYLIC BRUSH
Simply Painting MEDIUM ACRYLIC BRUSH
Simply Painting ROUND ACRYLIC BRUSH
Simply Painting PALETTE OR A LARGE WHITE PLATE OR TRAY
WATER CONTAINER • OLD CLOTHS • A PENCIL AND A RULER
AN EASEL AND A HAIRDRYER, IF YOU HAVE THEM.

ACRYLIC PAINTS
TITANIUM WHITE • CADMIUM YELLOW PALE HUE
RAW SIENNA • ULTRAMARINE BLUE • BURNT UMBER
VERMILION HUE • PHTHALO GREEN

11: Aasleagh Falls

Asasleagh Falls is a beautiful place in the West of Ireland. It is close to the village of Leenane which is at the head of Killary Harbour. At seven hundred feet deep Killary Harbour is the deepest inlet in Ireland and divides the counties of Mayo and Galway. If you look at the finished painting you will notice the horizon line is just on the falls itself. So, let's start this painting with the horizon line.

Step 1: Have - Horizon

Set the canvas board up in landscape fashion, that is, resting on one of its long sides. Using a pencil, draw the horizon line straight across the canvas board, about 1/3 of the way up from the bottom of the board.

Step 2: Some - Sky

Put some Titanium White, Ultramarine Blue and Vermilion Hue onto the edge of the palette. Then, taking 80% Titanium White with 20% Ultramarine Blue, drag some paint to the centre of the palette and paint the sky.

109

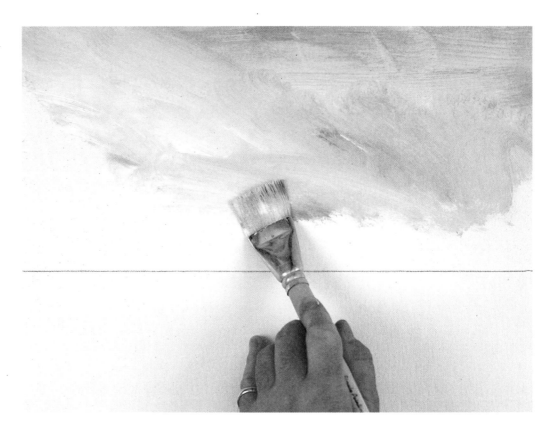

To make a plain sky with an even coat of blue, draw your brush lightly across the canvas board.

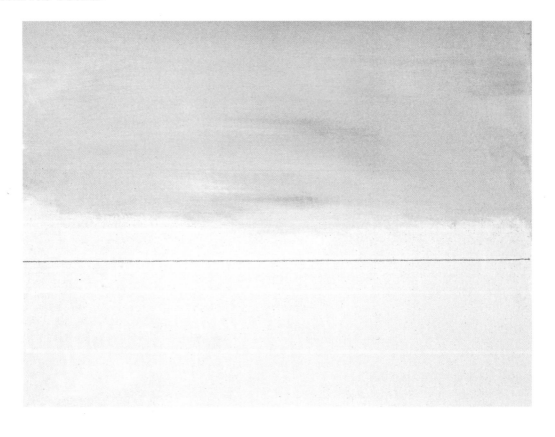

Now, while the sky is still wet, mix some Ultramarine Blue, Vermilion Hue and Titanium White on the palette. I want to make a blueish/reddish colour. If this colour turns out too dark, add a little bit more Titanium White.

Apply some to the sky as in the picture below.

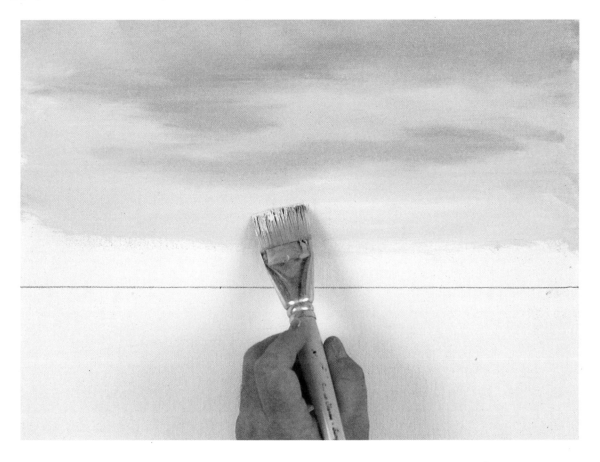

Step 3: More - Middleground

Mountains

Look at the finished painting before starting to paint the mountains. Now, put out some Raw Sienna on your palette and take your large brush from the water and dry it on the cloth. Using a mixture of 60% Titanium White, 20% Raw Sienna and 20% Ultramarine Blue, paint the letter M for the mountains.

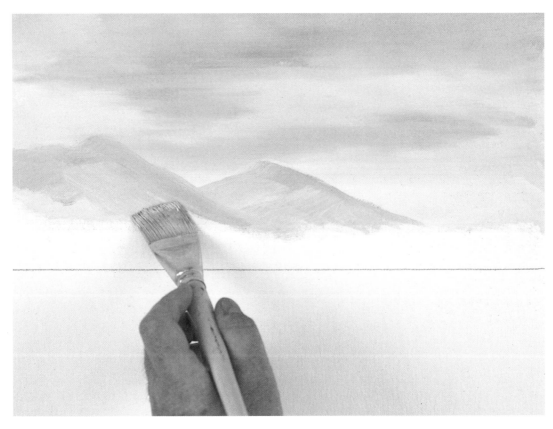

As you paint the mountain on the left, add a little more Raw Sienna, to give the mountain a greenish hue.

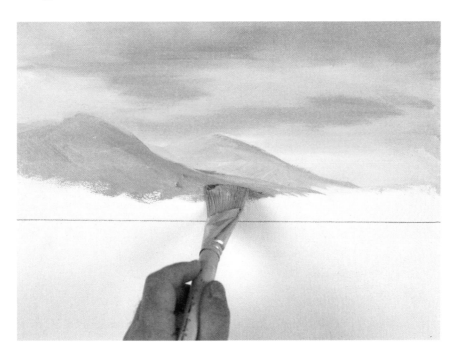

Next we paint the foothills, which is the area between the mountains and the horizon line. Put out some Cadmium Yellow Pale Hue on the palette and, with a mixture of 60% Titanium White and the rest made up of equal amounts of Cadmium Yellow Pale Hue, Raw Sienna and Ultramarine Blue, paint the foothills down as far as the horizon line.

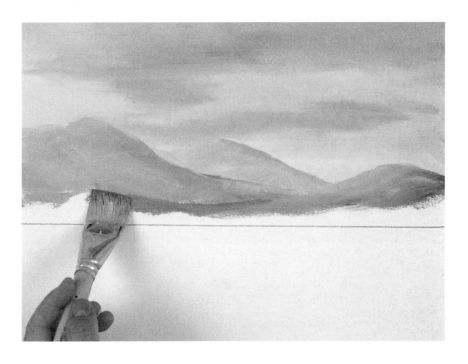

Put out some Burnt Umber on the edge of your palette and using the large brush with the Burnt Umber only, paint along the horizon line.

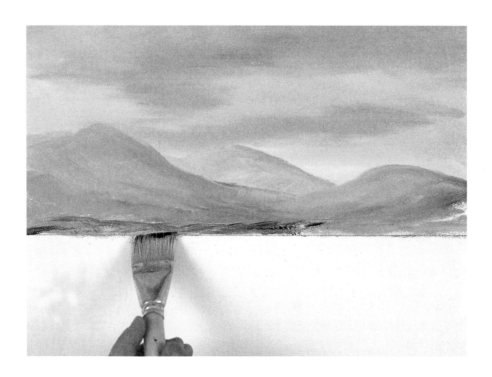

Now using 50% Raw Sienna and 50% Vermilion Hue with the large brush, paint the bottom of the mountain on the right. Put your large brush back into the water and clean it.

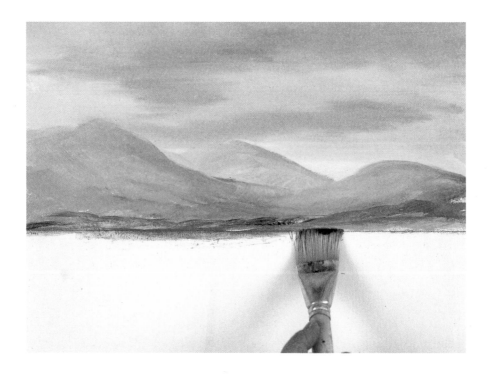

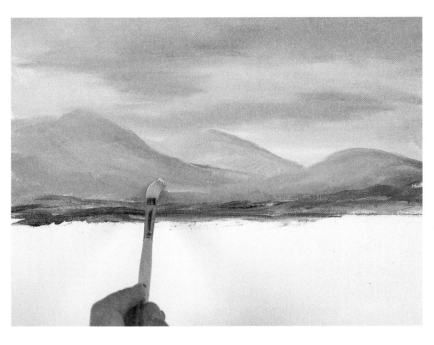

With 50% Titanium White and 50% Cadmium Yellow Pale Hue, use the medium brush to create a sunlit valley between the mountains.

Take your large brush from the water and dry it on the cloth.

To create the riverbank in the distance, add a bit of Burnt Umber in the centre of the picture along the horizon line.

Replace your large brush in the water and clean it.

Now we are ready to paint the falls.

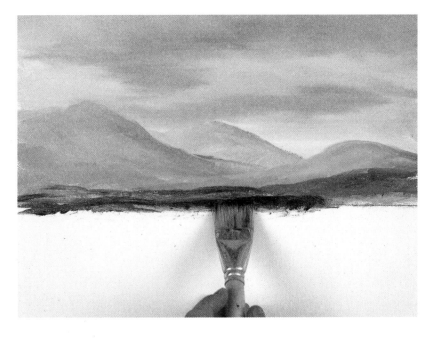

Step 4: Fun - Foreground - The Falls

Take your medium brush from the water and using Titanium White and Ultramarine Blue, equal amounts of each, paint the water above the falls, immediately under the horizon line.

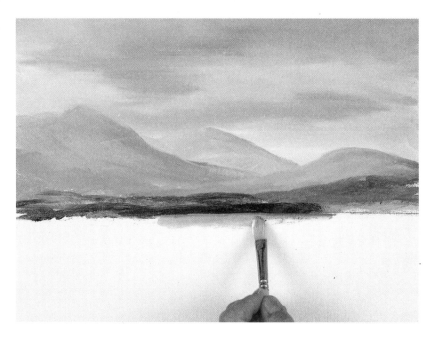

Using the medium brush with Titanium White and a tiny amount of Ultramarine Blue, 90% Titanium White and 10% Ultramarine Blue, paint the falls under the horizon line. Use broad downward strokes (see Brush Strokes Chapter 3).

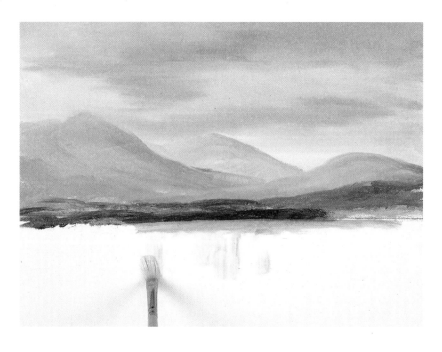

While the falls are still wet, paint the rocks in the centre of the waterfall and the small rock at the top of the waterfall. Use dabbing strokes with the medium brush and Burnt Umber only.

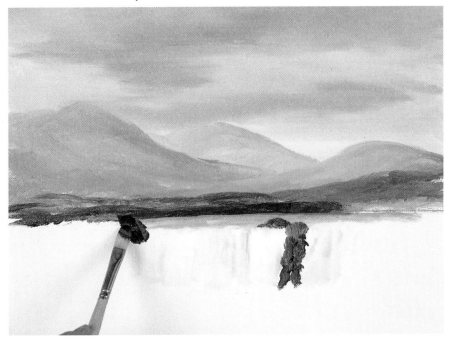

For the rocks on the right and left of the waterfall, take some Burnt Umber, Ultramarine Blue and Vermilion Hue, about 1/3 of each, and paint them, using dabbing strokes with the medium brush. Paint the rocks at a slight angle, not straight down, because the water rushes outwards from the falls to cover the rocks.

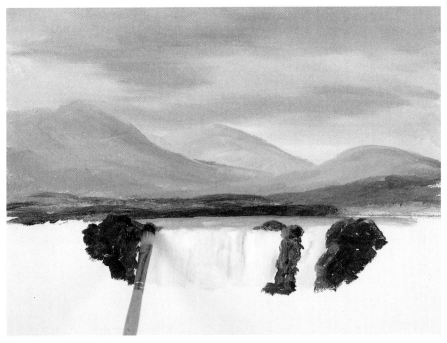

Using the medium brush, with some Raw Sienna added to the mix, paint the ground beside the rocks on the left. Put the medium brush back into the water and clean it.

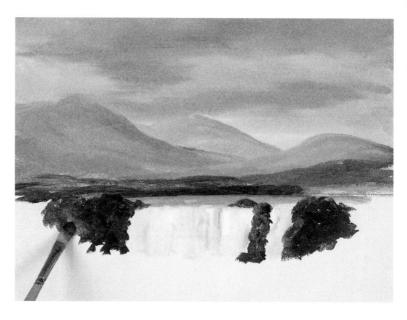

Now let's paint the fir trees on the right hand side.

Take your large brush from the water and dry it on the cloth. Put out some Phthalo Green on the edge of your palette and using Phthalo Green, Ultramarine Blue and a little bit of Cadmium Yellow Pale Hue, paint the fir trees.

Use the corner of the brush and just dab it on the canvas board. Start from the bottom and work up. Let the brush do the work. To lighten the trees, add a little bit of yellow and dab it on top of the green. This will give them some tones.

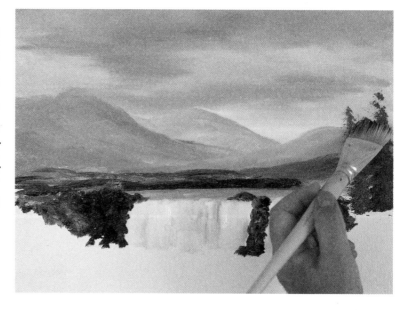

Next with your finger, scratch out the tree trunks. Start from the bottom and work upwards, don't put in too many.

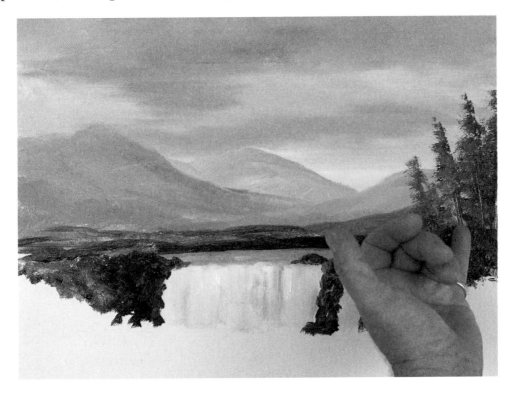

With the large brush fill in the riverbank below the fir trees using 80% Cadmium Yellow Pale Hue along with 20% Phthalo Green.

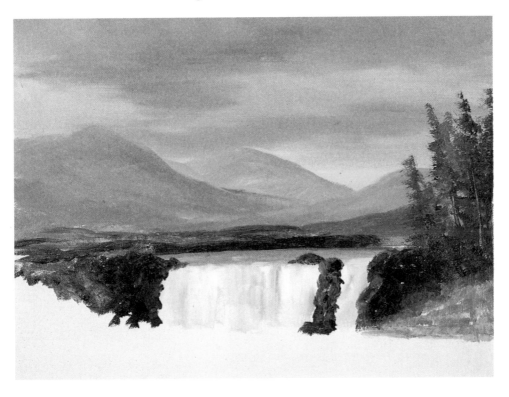

Add a little shadow under the bank to the right of the waterfall, using the large brush and Burnt Umber only.

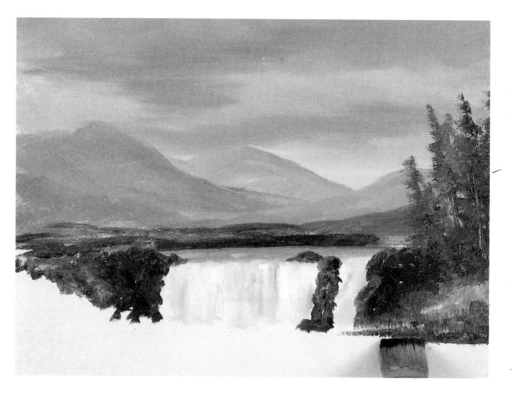

Now, using 40% Cadmium Yellow Pale Hue, 40% Raw Sienna and 20% Burnt Umber, paint the large riverbank to the left of the falls, at the bottom of the picture.

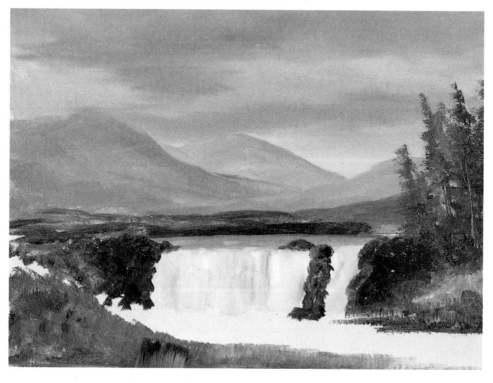

Remove your medium brush from the water and dry it on the cloth. Paint the water at the bottom of the falls, using Titanium White and Ultramarine Blue.

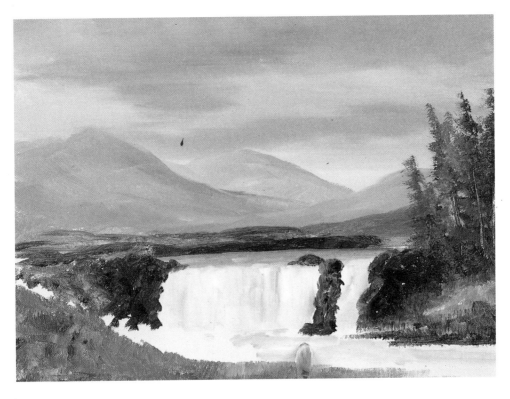

Now with this colour and using narrow vertical strokes, paint some shadow areas in the the water as it cascades down the falls.

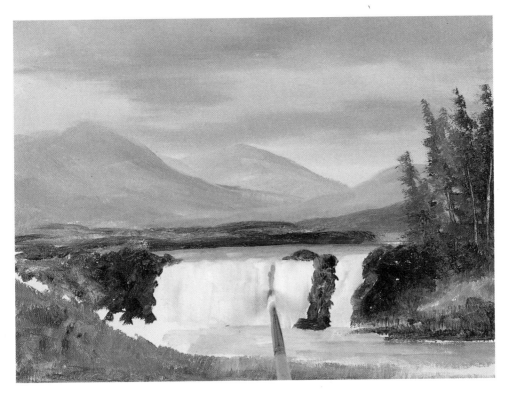

Put your medium brush back into the water and clean it. Now, use your medium brush to paint some Titanium White at the bottom of the waterfall.

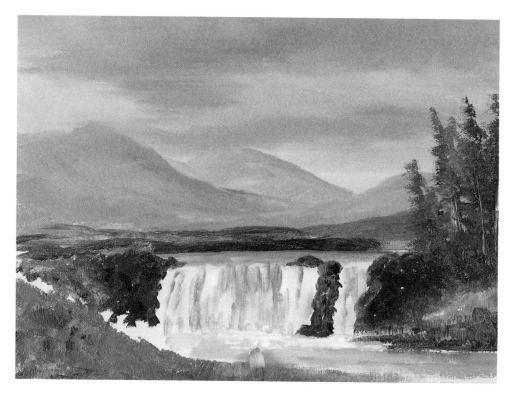

Darken the water at the top of the waterfall using Ultramarine Blue with a tiny amount of Titanium White.

The bushes in the foreground are gorse bushes. These are prickly bushes with a yellow flower, which bloom in the spring. They are a strong colour and are painted using short vertical strokes with the medium brush and equal amounts of Phthalo Green and Raw Sienna.

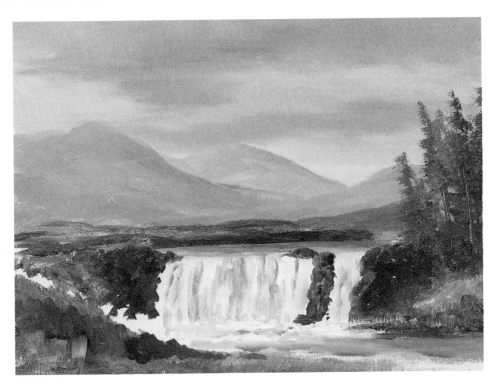

Now dry the gorse bush first before moving on.

Now add the flowers around the top of the gorse bushes, using Cadmium Yellow Pale Hue and the large brush.

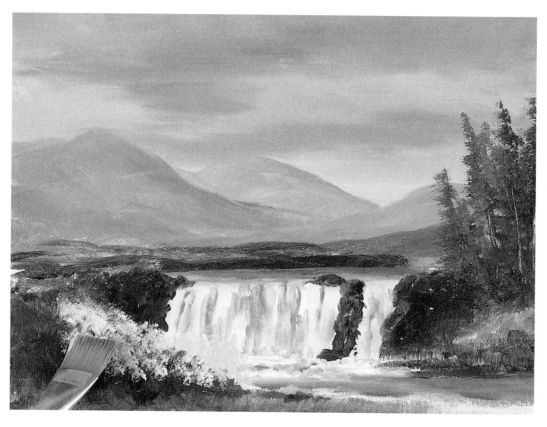

Add a little bit of Titanium White to the mix on the brush and it will make the paint more opaque, that is, it will cover better.

There is a little bit of gorse bush around the top of the rocks on the left of the falls. I want you to paint this on your own.

First paint it with green, then dry it. Finally paint ·the highlights just as you did with the large bushes. This time use the medium brush.

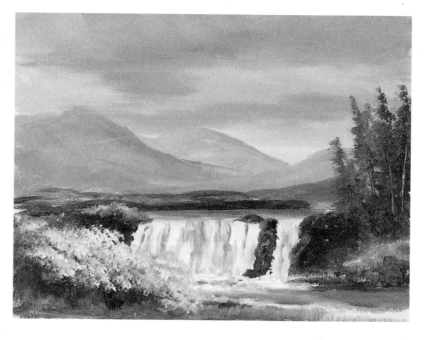

The rocks at the bottom of the waterfall are next. These are painted, using equal amounts of Ultramarine Blue and Burnt Umber. Using your small brush make sure that the base of each rock is parallel to the horizon line.

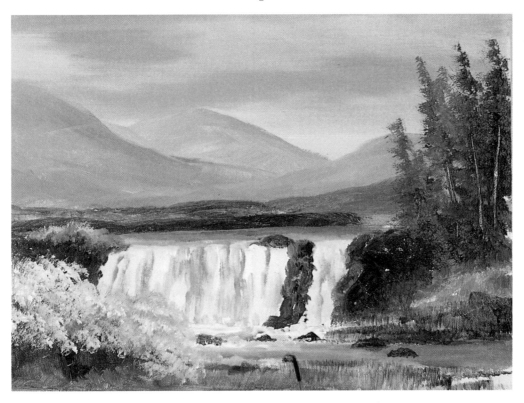

Finish the water at the bottom of the falls by adding some Titanium White around the rocks. This will create the effect of water rushing around the rocks.

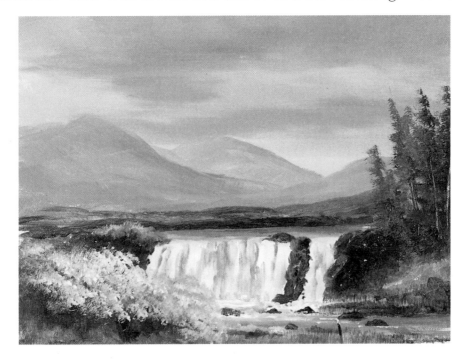

The last thing I do is paint my little bird on the left hand side. You can paint a few more of his friends on the right hand side above the fir trees.

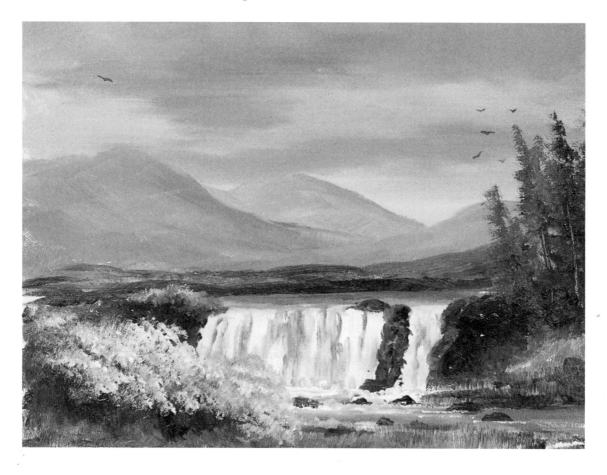

All that's left to do is sign the painting.

As I have said many times before, if you frame any of your pictures you will be amazed how much they improve.

I always remember hanging my first picture, I couldn't believe how well it looked. You try it and **Have Some More Fun.**

Dear Reader,

Well, sad to say, we have come to the end of another book. I hope you enjoyed it and that the results are hanging on your walls and those of your friends and family. I am sure you now realise that anyone can paint and also, what great fun this wonderful hobby can be.

One of the nicest things about painting is that you are never lonely with a paint brush - believe me it's true. I have often started to paint in the morning and did not notice the hours passing until night time. I know of no other hobby that gives so much pleasure and of course, you can paint anywhere. I have painted in bed when sick and even on aircraft.

So having said that, I am off once more to the West of Ireland to paint, and I hope you enjoyed **Simply Painting** and that you too, will have some more fun, **Simply Painting.**

Frank Clarke